IMAGES
*of America*

# CENTER CITY PHILADELPHIA
# IN THE 19TH CENTURY

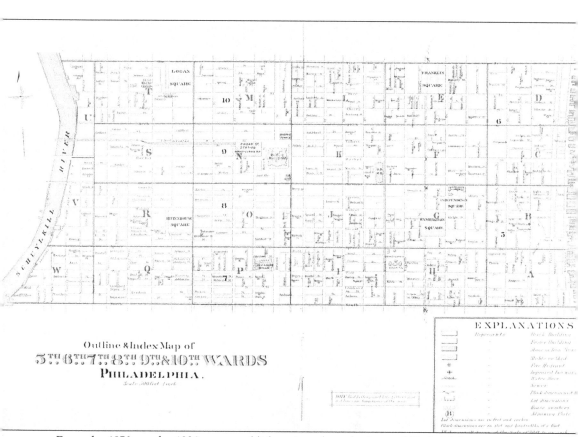

Outline & Index Map of
5TH 6TH 7TH 8TH 9TH & 10TH WARDS
PHILADELPHIA.

From the 1870s to the 1930s, map publishers issued ward atlases of Philadelphia to inform the public about the development and real estate value of sections of the city. In place of a table of contents, index maps provided the key to the streets delineated in the atlas. This 1885 index map shows Center City, the area documented in this book, and includes a number of the sites described by the authors.

*On the cover:* Fourth Street north of Walnut Street bustles with pedestrian and vehicular traffic in this 1890s photograph by Philadelphia commercial photographer Robert Newell. (Courtesy of the Library Company of Philadelphia.)

IMAGES
*of America*

# CENTER CITY PHILADELPHIA
# IN THE 19TH CENTURY

The Print and Photograph Department of
the Library Company of Philadelphia

ARCADIA
PUBLISHING

Published by Arcadia Publishing
Charleston, South Carolina

Library of Congress Catalog Card Number: 2005938877

For all general information contact Arcadia Publishing at:
Telephone 843-853-2070
Fax 843-853-0044
E-mail sales@arcadiapublishing.com
For customer service and orders:
Toll-Free 1-888-313-2665

Visit us on the Internet at www.arcadiapublishing.com

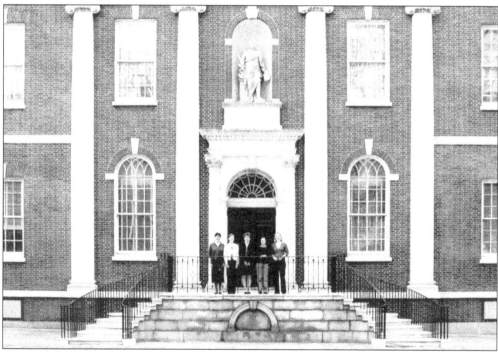

The authors (left to right) Jenny Ambrose, associate curator of prints and photographs; Charlene
Peacock, print department assistant; Sarah Weatherwax, curator of prints and photographs; Erika
Piola, visual materials cataloguer; and Linda Wisniewski, graphics assistant stand on the steps of the
American Philosophical Society's Library Hall, a replica of the Library Company of Philadelphia's
first permanent home. The Library Company, now located at 1314 Locust Street, is an independent
research library opened free of charge to the public. (Photograph by Frank Margeson.)

# CONTENTS

# PREFACE

In celebration of the Library Company of Philadelphia's 275th anniversary, we are pleased to partner with Arcadia Publishing to produce this book featuring a sampling of the library's rich photographic holdings. As America's oldest cultural institution, the Library Company has amassed an impressive collection of books, pamphlets, broadsides, prints, and photographs documenting every aspect of the history and background of American culture from the Colonial period to the end of the 19th century. The importance of the library's visual collections was formally recognized in 1971 with the creation of a separate Print and Photograph Department dedicated to actively developing, preserving, and providing access to our graphic materials. Specializing in images of Philadelphia and works by regional artists, the collection contains more than 75,000 prints, photographs, and original works of art. In this book we have highlighted our collection of 19th-century photographs of Philadelphia, many of which were donated by the photographers and antiquarians who created and collected them.

The Print and Photograph Department staff—curator Sarah Weatherwax, associate curator Jenny Ambrose, visual materials cataloguer Erika Piola, print department assistant Charlene Peacock, and graphics assistant Linda Wisniewski—devoted many hours to producing this book. Each of us searched through hundreds of photographs to select images, conducted research, wrote captions, and worked on the layout. Linda Wisniewski displayed her digitization skills and her constant good nature by scanning most of the images in this book. Images that could not be scanned were digitally photographed by the Library Company's longtime photographer Will Brown. Frank Margeson took the author photograph, and Library Company director John Van Horne and Chris Van Horne edited the text. We would like to extend our special thanks to board members, colleagues, friends, and family who have provided encouragement and support throughout the project. We hope our combined efforts have produced a book that displays the strength of the Library Company's photograph collection and illuminates for our readers life in 19th-century Center City Philadelphia.

# INTRODUCTION

Within the covers of this book, we are featuring 19th-century photographs of the places and people of Center City Philadelphia. All the images in the book are from the Print and Photograph collection of the Library Company of Philadelphia, a rare book and research library founded by Benjamin Franklin and a group of his friends in 1731. In keeping with William Penn's original plan for Philadelphia, Center City is defined as running from the Delaware River to the Schuylkill River and from Vine Street to South Street. As laid out on maps in the 1680s, Penn's design for a "greene Country Towne" provided for large lots in a grid pattern broken up by five squares originally known by their geographic location in the grid and in 1825 renamed for prominent figures in Philadelphia history. Penn envisioned a city composed of large residential lots that "hath room for House, Garden and small Orchard" evenly spaced between the two rivers. Early Philadelphians, however, clustered along the Delaware River in the east near the busy wharves that connected Philadelphia with the world. Large lots near the river were subdivided, and small streets and alleys were cut through the grid. Development along the river expanded outside of the city's northern and southern boundaries, while the area to the west remained largely undeveloped.

Throughout the 18th century and into the early 19th century, Philadelphia continued to grow and solidify its importance as a major American city and maritime center. Philadelphia, which during this period was synonymous with Center City, served as a political, commercial, and cultural epicenter. Between 1790 and 1800, Philadelphia also served as the nation's capital, giving the city an even more cosmopolitan atmosphere. The city teemed with people selling their produce, buying the latest imported goods, conducting business, petitioning the government, or pursuing an education. Penn's promise of religious toleration attracted groups practicing a wide variety of religions who constructed numerous houses of worship in Center City. As befitting a city of such importance, Philadelphia fostered many innovations including the establishment of the nation's first lending library, the Library Company of Philadelphia in 1731; the nation's first hospital, Pennsylvania Hospital in 1751; and the nation's oldest trade organization, Carpenters' Company in 1724. The wealth generated by the city's commerce led to the chartering of America's oldest commercial bank, the Bank of North America, in 1782 and the establishment of America's first savings bank, the Philadelphia Saving Fund Society, in 1816. The city was flourishing, but by 1800, still only a scattering of buildings stood west of Seventh Street, and Penn Square stood at the edge of mostly open countryside.

As the 19th century progressed, Philadelphia's economic base expanded beyond commerce and finance and the city embraced the Industrial Revolution. Large numbers of immigrants, many from new ethnic and religious groups, flocked to Philadelphia to labor in the iron, textile, and railroad industries. In some decades, the city's population increased by as much as 40 to 50 percent. Center City, however, was no longer the area experiencing the largest population growth, and in recognition of the increasing size and importance of the county outside Center City, the city and county consolidated in 1854.

As all of Center City became developed in the 19th century, certain areas became associated with particular activities or people. Market Street, originally known as High Street, had been a commercial area as early as the 1693 establishment of market stalls in the center of the street, and Market and Chestnut Streets formed the heart of the 19th-century shopping district. The 400 block of Chestnut Street earned the name Bank Row for its high concentration of financial institutions. In the mid-19th century, Walnut Street west of Seventh Street was considered by many the most fashionable residential address in the city, while later in the century houses around Rittenhouse Square attracted some of the city's most prominent residents. Factories and commercial buildings began taking the place of residences along Arch and Cherry Streets and in

the oldest section of the city along the Delaware River. Large scale industries were pushed to the westward edge of Center City along the Schuylkill River or outside Center City completely.

The photographs selected for this book reflect Philadelphia's transformation from an 18th-century seaport into a leading manufacturing center, and the impact these changes had on the built environment of Center City and on its inhabitants. The photographs depict the construction of new buildings such as the Cathedral Basilica of SS. Peter and Paul, built in response to the swell of Catholic immigrants, and the demolition or alteration of older buildings, particularly those along the city's eastern edge, as the city pushed westward. Photographers recorded entirely new types of urban architecture such as Wanamaker's Grand Depot, Philadelphia's first department store, and the spectacular railroad stations owned by the competing railroad lines serving the city in the late 19th century. Yet photographers did not neglect Philadelphia's proud history and so turned their cameras to such venerable structures as Christ Church, the Chestnut Street Theatre, and Independence Hall.

The history of Philadelphia and the history of American photography were closely intertwined during the 19th century. The Library Company's collection of 19th-century photographs includes work by the city's (and America's) leading commercial practitioners, amateur photographers from some of Philadelphia's prominent families, and professional artists exploring the possibilities of a new medium. Work by some of the city's early photographic experimenters, including William and Frederick Langenheim and Robert Bird, will be found in this book. Photographs by Frederick DeBourg Richards, who was hired by local antiquarians in the 1850s to document Philadelphia's disappearing 18th-century architectural landscape, are well represented, as is the late 19th-century work of commercial photographer Robert Newell. The inclusion of work by amateur photographers and friends Marriott C. Morris and George Vaux provide a look into the interests of two prosperous Philadelphia Quaker families.

What these photographers chose to record through their camera lenses and what images the Library Company chose to collect cannot, however, give us a complete view of Center City (or any other section of the city) in the 19th century. For the most part, photographers took images of what was familiar and comfortable to them or, in the case of the professionals, what they were paid to shoot. As the authors selected images for this book, they tried to keep these biases in mind and strove to tell as multifaceted a story of the people and places of Center City Philadelphia in the 19th century as possible using only the library's collections. The authors have not tried to create a comprehensive history of Center City, but instead have attempted to give readers a sense of the vitality of life in a major American city. Other authors using our collection or another collection might tell a somewhat different story that would be equally valid. Center City Philadelphia in the 19th century had many stories to tell.

# One

# CULTURAL INSTITUTIONS

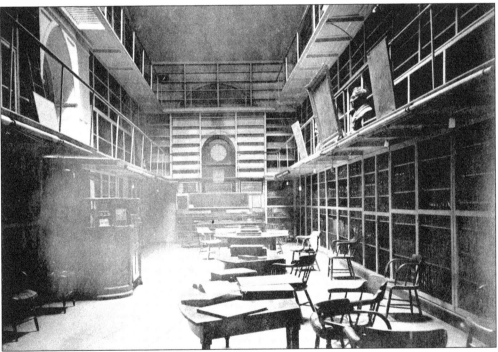

The Library Company of Philadelphia holds the distinction of being America's oldest cultural institution and first lending library. Benjamin Franklin and other founding members signed the Articles of Association in July 1731 and began collecting dues to purchase history, literature, and science books from London. Membership and collections (including museum objects) grew rapidly, eventually requiring the erection of a building. On New Year's Day 1791, the Library Company opened its own building on Fifth and Library Streets just south of Chestnut Street, after having been housed in private quarters, the State House, and Carpenters' Hall. This interior view was taken in 1879, shortly before the building was sold and the collections were split between two new buildings.

In 1887, the old Library Company building was demolished to make way for the Drexel Building. The office building was demolished in the late 1950s when the American Philosophical Society (founded 1743) built its library on the site, reproducing the Library Company's original facade as designed by William Thornton (see page 4).

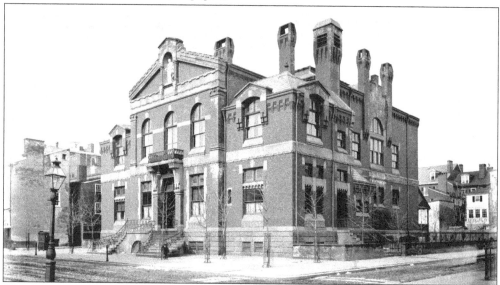

This crisp 1884 image of the Library Company's Juniper and Locust Street branch reveals that architect Frank Furness was inspired by the original Fifth Street building's designs. Furness, known for his eccentric sensibilities, recalled William Thornton's curved double steps, pediment, and arched niche. Its location near Broad Street addressed the westward development of Philadelphia; a committee had earlier determined that 86 percent of the Library Company's city-residing members lived west of Tenth Street. To further accommodate this group, the new building featured "well-warmed and ventilated" reading rooms, a ladies' sitting room, evening hours, and telephone communications to other libraries. The building was demolished in 1940.

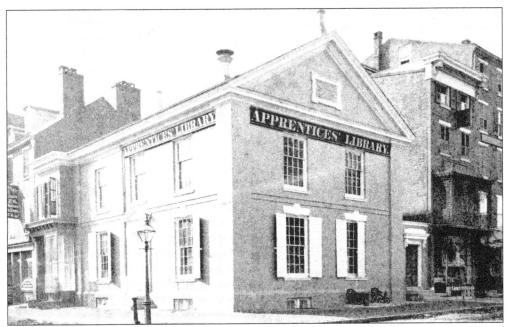

The Apprentices' Library was founded in 1820 to provide young people free access to books. No idle reading of sensational fiction was done here. The board of managers reviewed every book before placing it on the shelf, with the goal of promoting "orderly and virtuous habits," the diffusion of knowledge, and betterment of scientific skill. The library rented this building (designed in 1783 by Timothy Matlack and Samuel Price Wetherill, and still standing) at 500 Arch Street from the Society of Free Quakers from 1841 until 1897 and provided separate reading rooms for girls and boys. This view dates from about 1870.

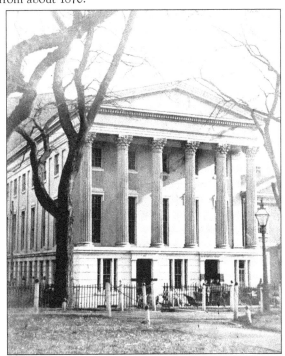

William L. Johnston designed this Greek Revival edifice, constructed 1844–1845, at the southeast corner of Fifth and Library Streets for the Mercantile Library Company of Philadelphia, which formed in 1821 as a member-supported institution for merchants and clerks. Initially serving the specific interests of bankers, traders, and accountants, by the late 19th century, the library became a place for the general public to utilize its collection of newspapers, magazines, and novels. Pictured here in 1858, the library relocated in 1869. The building was demolished around 1925.

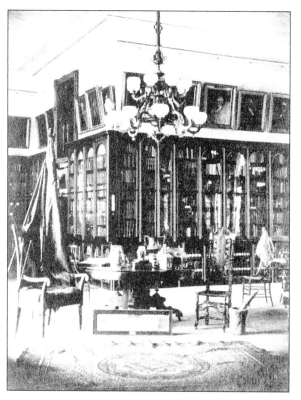

This photograph showing artifacts from the Historical Society of Pennsylvania's collection was taken around 1868, when the society shared a space with the Athenaeum of Philadelphia on Sixth Street at Washington Square. The photographer of this image, John C. Browne, was a well-respected member of the Historical Society of Pennsylvania, which was founded in 1824. Today the institution documents and illuminates the history of Philadelphia and the state of Pennsylvania through preservation, access, education, and publishing from its current location at Thirteenth and Locust Streets. The wampum belt purportedly from William Penn's treaty with Native American tribes rests on the floor against the table.

In January 1812, a group of six young men with an interest in natural history met to discuss their research and exchange knowledge in an open environment free from political or religious leanings. The Academy of Natural Sciences, the western hemisphere's oldest institution of its type, grew out of their meetings. Early members collected bird, mammal, insect, mineral, and botanical specimens, and books. Eventually a museum and library opened to the public. The academy moved to this John Notman–designed building (seen on the left side of this c. 1868 photograph) at the northwest corner of Broad and Sansom Streets in 1840, added the top story in 1855, and moved to its current location in 1876.

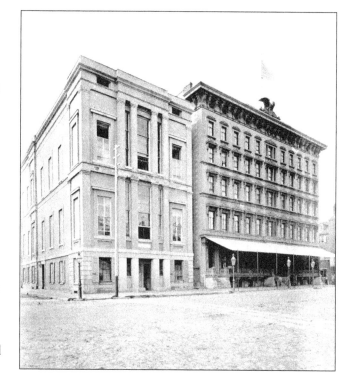

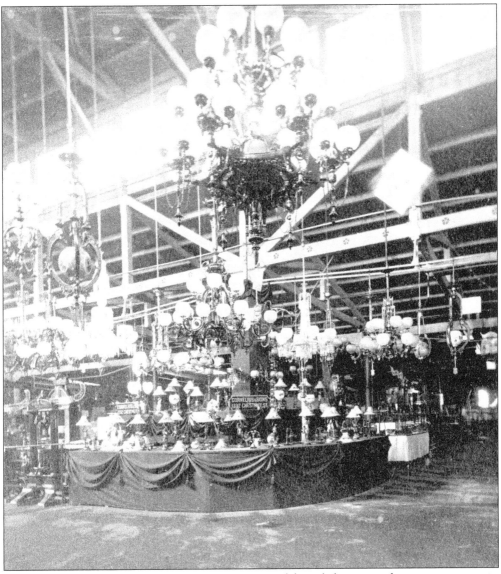

Incorporated in 1824, the Franklin Institute promoted knowledge in mechanic arts among its science-minded members. The institute provided for its members a library and reading room, lectures, classes, a monthly journal, and it periodically held displays of American-made products. This view of the 1874 Exhibition of American Manufactures highlighted prize-winner Cornelius and Sons, maker of gas fixtures and lamps. The Franklin Institute, today an educational science and technology museum open to the public, was located on Seventh Street just below Market Street, in the John Haviland–designed building now occupied by the Atwater Kent Museum of Philadelphia.

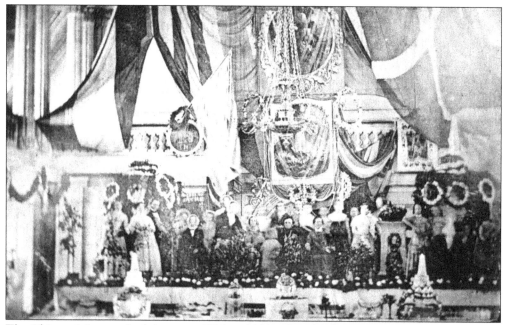

The Chinese Museum, built between 1836 and 1838 after the designs of English architect Isaac Holden, was a veritable multiuse venue. The two-story marble building exhibited Nathan Dunn's impressive collection of wax figures dressed in authentic Chinese clothing set amidst Chinese furniture, decorations, and rooms, along with the Philadelphia Museum Company's holdings of artist Charles Willson Peale's collection of paintings, bones, stuffed animals, and curiosities. Between 1842 and 1844, both museums left the building due to decreased attendance and profits, but the space at the northeast corner of Ninth and Sansom Streets, capable of holding 8,000 people, continued to host balls, political conventions, plays, lectures, public meetings, and exhibitions, such as the Exhibition of American Manufactures sponsored by the Franklin Institute, pictured above in October 1844. The smoldered remains of the building are shown below, after a devastating fire destroyed it on July 5, 1854.

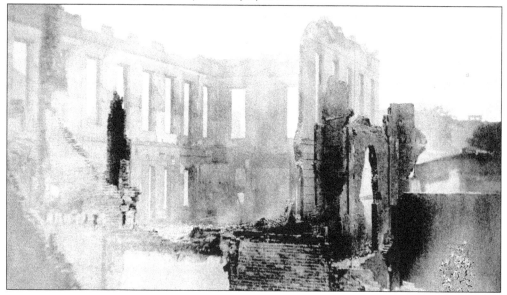

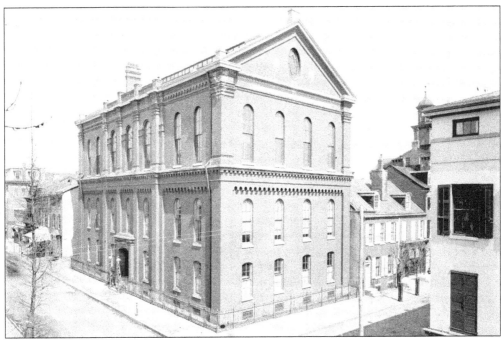

Though founded in 1787, the College of Physicians of Philadelphia only moved into its own building in 1863 at the northeast corner of Thirteenth and Locust Streets, where it remained until 1909. This building designed by James H. Windrim might not have been constructed had it not been for Thomas D. Mütter's gift to the institution of a significant collection of medical specimens and a $30,000 endowment with the stipulation that a fireproof building to house the collection be erected within five years of accepting the gift. Additional donations of specimens, instruments, and models caused the College of Physicians to add a third story to the building, as shown here around 1885, to accommodate the Mütter Museum.

The Soldiers' Reading Room opened its doors to sick and wounded Union soldiers temporarily stationed in Philadelphia. Mary McHenry established the institution in October 1862 (about the time this image was taken) on Twentieth Street between Market and Chestnut Streets. Soldiers had access to a library of almost 2,000 books, periodicals, and newspapers, as well as opportunities to hear lectures, watch performances, play games, have a meal, and even take night classes. Largely run by women, the Soldiers' Reading Room provided not only "warmth and welcome" to homesick soldiers, but an alternative to gambling and drinking.

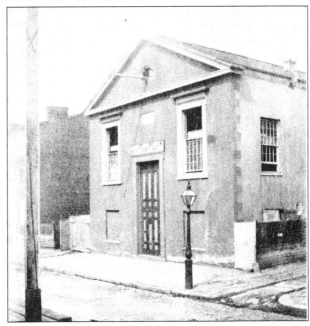

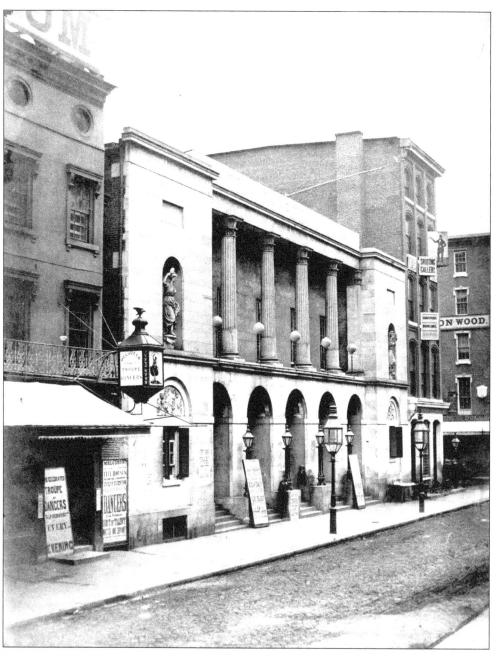

Referred to as the New Theatre to distinguish it from the Southwark, or Old, Theatre, the Chestnut Street Theatre opened in 1794 near the northwest corner of Sixth and Chestnut Streets. After fire destroyed its building in 1820, the Association of the Proprietors of the New Theatre sold shares in the property and hired William Strickland to design a new building. Constructed at the same location in only eight months, the imposing marble structure included the statues of Comedy and Tragedy sculpted by William Rush, which survived the fire. To celebrate its opening, the managers held a contest for the best opening night address. Prize winner Charles Sprague's verses were so well received that his address was read a second night. The theater is shown here in 1855, shortly before being demolished.

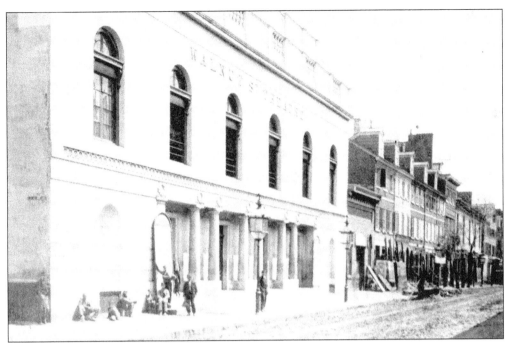

The row houses on the north side of the 800 block of Walnut Street shown here around 1865 no longer exist, but the Walnut Street Theatre still stands, holding the title of America's oldest theater. Built by Victor Pepin and Jean Breschard, circus promoters who brought their equestrian and human acts to the United States from Europe, the theater has operated continuously since opening in 1809 as the New Circus. Architect John Haviland made extensive alterations in 1828, when it permanently changed its name to the Walnut Street Theatre.

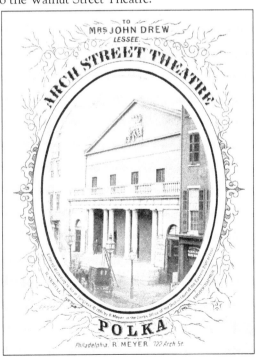

Though the Arch Street Theatre opened in 1828, it particularly thrived from 1861 to 1892 under the careful management of London-born Louisa Drew (née Lane), the wife of John Drew. Daughter of an actor and a singer, Louisa herself was an accomplished actress who ran the successful stock company into her early 70s. The William Strickland–designed building, pictured here on an 1861 sheet music cover, featured a marble facade, crystal chandeliers, a hand-painted dome, and spacious seating for 1,911 attendees. Demolished in 1936, the theater was located at 609–615 Arch Street.

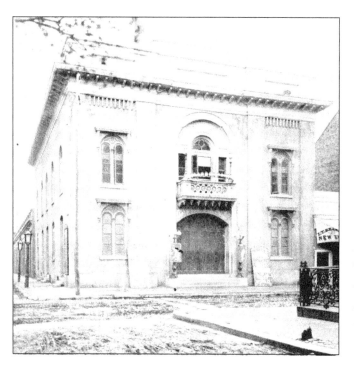

Many of the country's well-known minstrel players crossed the stage of the Eleventh Street Opera House at one point before the building was demolished in 1911. One of the most famous minstrel companies, Carncross and Dixey, managed and performed at the theater during and after the Civil War. Their playbills are propped up outside the theater at Eleventh and Ranstead Streets in this *c.* 1864 photograph. Other comedic and musical groups that called the variety theater home during the second half of the 19th century included Sanford's Opera House and Dumont's Minstrels.

The Trocadero's origins date back to 1870, when the Arch Street Opera House opened its doors as a minstrel theater. Designed by Edwin Forrest Durang at 1003 Arch Street, the theater burned down and was rebuilt or altered several times within its first two decades, at some point losing the free-standing wreathed lyre above the cornice shown here around 1870. It operated under a succession of at least nine different names until settling on the Trocadero in 1896, at which time the stage mainly showcased burlesque and vaudeville groups. The Italianate-style building, which originally housed retail stores in the two flanks, is the nation's only 19th-century Victorian theater left intact, thereby earning its place on the National Register of Historic Places.

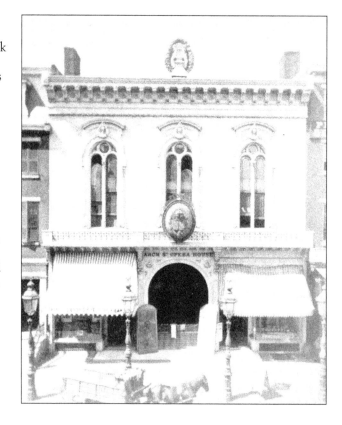

Robert Fox built his American Theatre in 1870 at 1021–1029 Chestnut Street, the former site of the Pennsylvania Academy of the Fine Arts (see page 108). In this view, dated around 1870, the faces of Comedy and Tragedy rest atop the cornice, while a large clock topped with an eagle ornaments the forward-projected entryway, flanked by playbills advertising "The Brigands." The interior featured seats for 1,656 people and box seats designed in a fishbowl shape. The Chestnut Street Opera House began operating out of the theater in 1880 and became a leading venue in the city. The building was demolished in 1940.

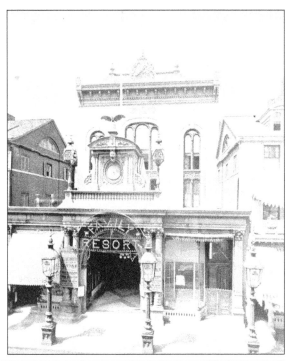

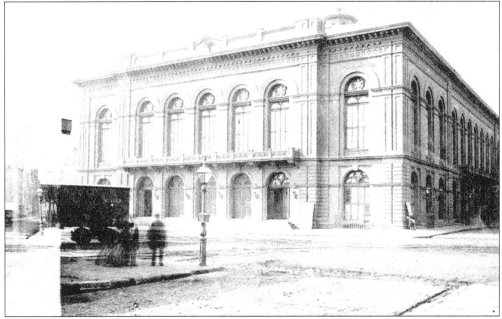

Built from 1855 to 1857 at the southwest corner of Broad and Locust Streets, then a quieter residential section of Philadelphia, the Academy of Music fulfilled the city's need for a large space for opera performances. Napoleon Le Brun and Gustav Runge designed the hall to be acoustically perfect, comfortable for audiences, and elegant in style. The best seats for its first opera performance, the American premiere of Verdi's *Il Trovatore* on February 25, 1857, sold for $1. The Academy of Music (shown above around 1865) continues to host world-class orchestra, ballet, and opera performances.

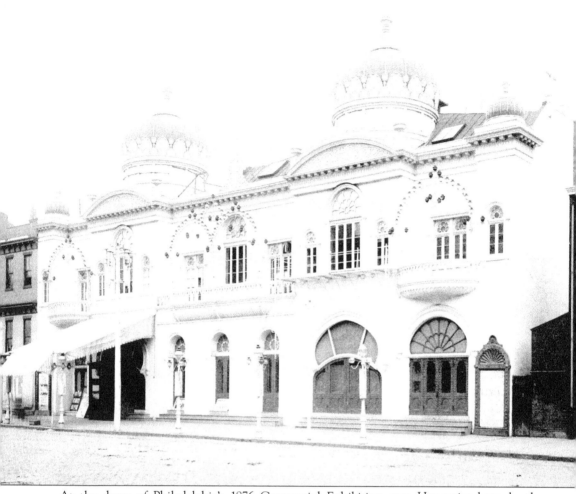

At the dawn of Philadelphia's 1876 Centennial Exhibition, two Hungarian-born brothers, Bolossy and Imre Kiralfy, erected a building like no other seen on Broad Street, featuring abundant arches, intricate carvings, and domes painted in bright primary colors and adorned with scalloped borders. Designed by Frank H. Loenholdt, the building drew heavily on Moorish influences, a striking contrast to the Academy of Music across the street. Located on the east side of Broad Street below Locust Street, Kiralfy's Alhambra Palace offered for Centennial Exhibition crowds huge, spectacular musical performances with costumed dancers, live animals, and special effects. The Broad Street Theatre bought the building in 1877, and it became one of Philadelphia's more popular halls. Captured here around 1880, the facade gradually lost some of its Moorish elements, and in 1937, the building was demolished.

# *Two*

# RESIDENCES

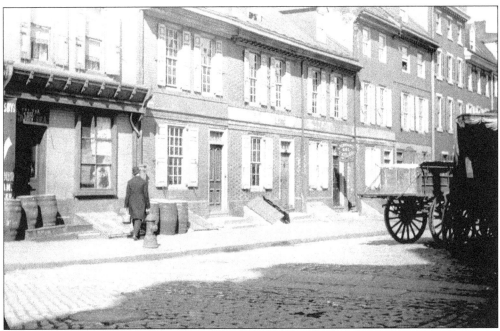

Philadelphia's numerous blocks of brick row houses are the most striking characteristic of the city's residential architecture. The great local abundance of high quality clay and lime—used to make mortar—contributed to the prevalence of this style. Photographed at the close of the 19th century, this image captures a row of 18th-century residences on the north side of the 200 block of Locust Street.

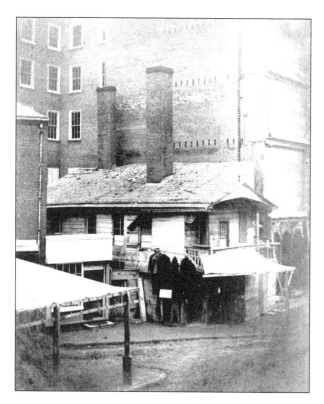

By the time this photograph was taken in January 1854, this 18th-century frame residence belonging to master builder Benjamin Loxley at the southeast corner of Little Dock (near Spruce) and Second Streets was a rare survivor in the burgeoning commercial district. After 1798, city ordinances prohibited wooden construction in this area, although it was still common in outlying neighborhoods. This image shows the tiny house, in use as a clothing store, dwarfed by adjoining brick factory buildings.

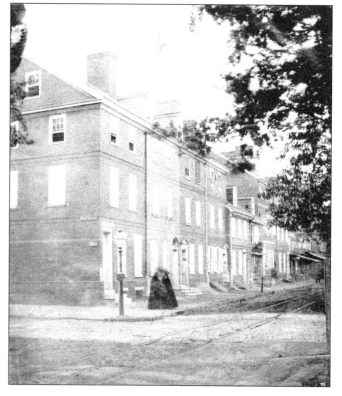

Taken on a hot summer day in August 1860, this photograph shows a block of row homes on Fourth Street at the corner of Pine Street shuttered against the steamy Philadelphia heat. Those who could afford to leave fled the city in the summer months, taking up residence in suburban "cottages" and summer resorts in order to escape the oppressive weather and the frequent outbreaks of disease.

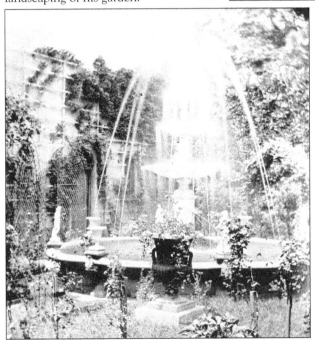

Many Center City row house residents made use of their "postage stamp" yards to create small private gardens hidden from view from the street. Behind his residence at 329 Pine Street, Joseph R. Evans took advantage of a double back lot to create a fenced garden complete with walkways, trellises, statuary, urns, and a large ornamental fountain. These two views from the early 1860s document the elaborate design and landscaping of his garden.

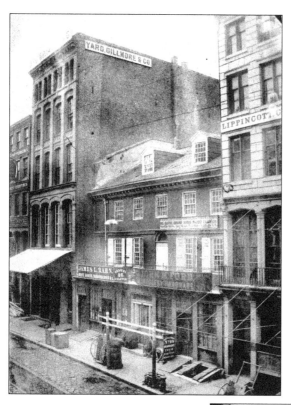

Many structures on the eastern side of Center City, near the Delaware River, were originally constructed as residences and later adapted for commercial use. This photograph, taken in May 1859, depicts the former mansion of wool merchant Benjamin Bullock on Third Street below Market Street. Modified with display windows at street level, two businesses—James L. Rahn's hosiery and glove shop and John M. Ford's saddlery and hardware store—occupy the building. Other homes on this block had already been replaced by taller commercial buildings.

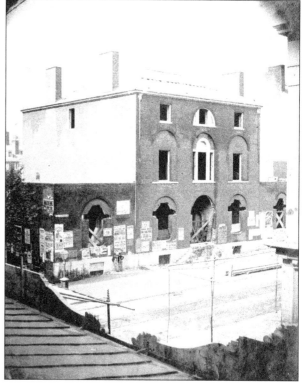

The Burd mansion on the south side of the 900 block of Chestnut Street became a casualty of the commercial push westward in 1861, when the house was demolished to make way for a row of storefronts. When it was constructed 60 years earlier for Philadelphia lawyer Edward Shippen Burd, after designs by Philadelphia architect Benjamin Latrobe, the house sat on the western edge of the developed city, and the site was surrounded by undeveloped or only partially developed lots.

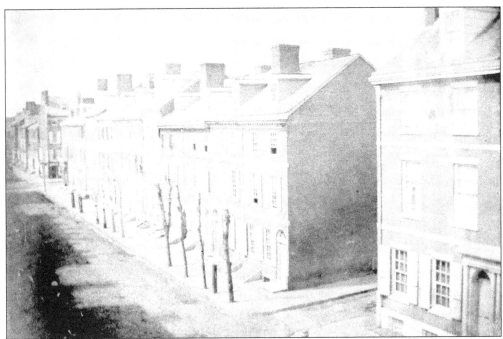

In January 1853, noted 19th-century author Robert Montgomery Bird captured this view of the north side of the 900 block of Filbert Street from the window of his house as part of a photographic experiment involving a new method for creating paper negatives. This photographic technique creates soft edges and gives the images their shadowy appearance. The earliest known photographs of this block, Bird's images of the neighborhood include a series of rooftop views showing a maze of shingled roofs and chimneys, as well as wooden fences and poles used for drying laundry.

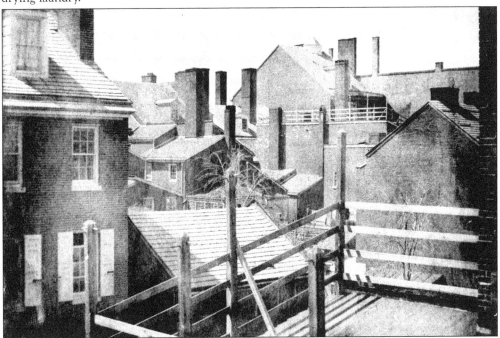

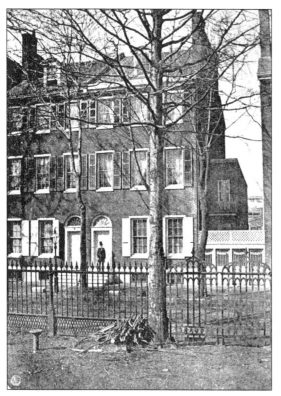

As older homes along the commercial corridors east of Broad Street were converted to businesses or demolished, new houses were being constructed to the west. This house, built around 1835 on North Merrick Street, was one of a growing number of large double townhouses that lined Penn Square by the end of the 1830s. John McAllister Jr., a noted optician and the house's original owner, posed on his front stoop for this photograph in March 1860. With the large front yard and the nearby square, McAllister could enjoy the "rural" character of the neighborhood while remaining within easy walking distance of his shop on the 200 block of Chestnut Street. The image below provides a partial view of two of the bedrooms.

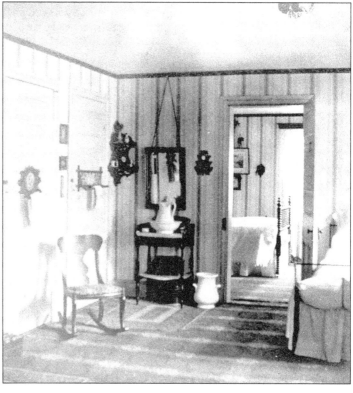

The Dundas-Lippincott mansion was constructed between 1840 and 1841 for banker James Dundas at the northeast corner of Broad and Walnut Streets on the site of the Vauxhall Gardens, a public pleasure garden that featured a restaurant, an open air theater, and many lovely old trees. For Dundas, who had a passion for horticulture, the lot was ideal. He incorporated elements of the older garden in the design of his grounds and constructed the large conservatories on the north side of the block. By the time the view of the parlor below was photographed, around 1875, the house had passed to Dundas's niece Agnes Keene Lippincott and her husband, Joshua Lippincott, a financier with large holdings in the coal industry. The image shows the striking ionic columns architect Thomas U. Walter used in the design of the interior.

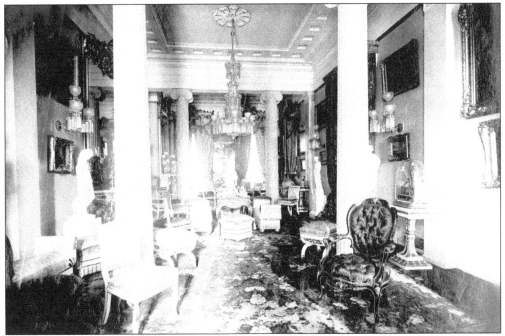

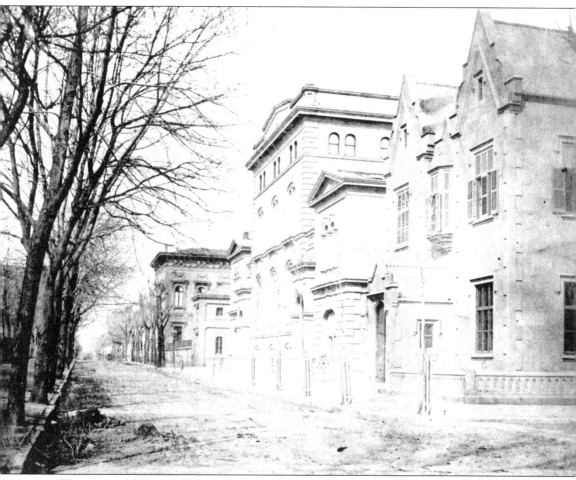

This spectacular row of Rittenhouse Square mansions on the east side of Eighteenth Street between Walnut and Locust Streets was erected between 1849 and 1857. Designed by three different Philadelphia architects, the houses exhibit strikingly disparate architectural styles reflecting a mid-century trend for increasing diversity in domestic architecture, which was made possible by a greater availability of varieties of stone. The Italianate home of hotelier George Edwards, visible in the distance, was designed by Napoleon Le Brun. Samuel Sloan's plans for Joseph Harrison Jr.'s Baroque Revival mansion with its symmetrical wings included a conservatory and a gallery for Harrison's extensive art collection. The adjoining Gothic Revival structure in the foreground was designed by John Notman as the rectory for St. Mark's Church.

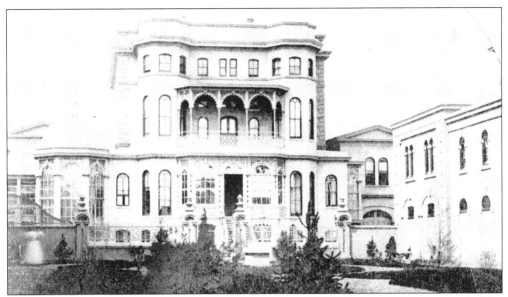

Joseph Harrison Jr., whose mansion appears at the center of the view opposite, conceived of the lot behind his home extending the entire width of the block as a private park to be shared by Harrison and the inhabitants of the elegant row he constructed along Locust Street between Seventeenth and Eighteenth Streets (see image below). This view of the garden, with its collection of ornamental shrubs and winding carriage road, also provides an unusual glimpse of the charming architectural features at the back of the mansion including the conservatory, the balcony, and the back gate.

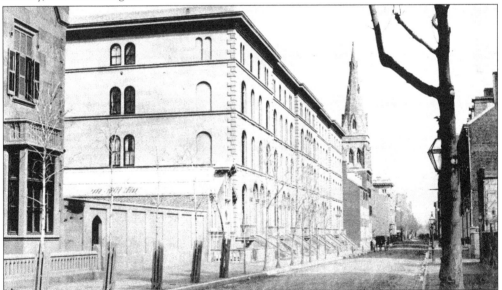

One of Philadelphia's few architect-designed rows, Harrison's Row consisted of a block of 10 elegant Italianate houses on the north side of Locust Street near Rittenhouse Square designed by Samuel Sloan. The homes shared a back garden (see image above) with Harrison's palatial mansion on Eighteenth Street, also designed by Sloan, and a block of stables to the north. Around the time this photograph was taken in March 1859, the homes were occupied by three merchants, three brokers, two "gentlemen," and an engraver, along with their families and servants.

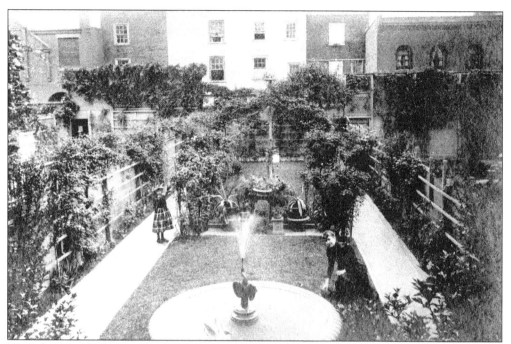

This photograph depicts the long narrow garden behind the home of physician Richard H. Townsend at 2028 Walnut Street in 1888. The image captures a profusion of roses in full bloom, a small girl reaching up to pick a flower, and a woman kneeling to place a restraining hand on her cat, stilling it for the photographer. The high fences and vegetation at the back of the garden mask a series of small stables bordered by two narrow alleyways that split the block. A group of smaller row homes, seen from the back in this image, lined Locust Street.

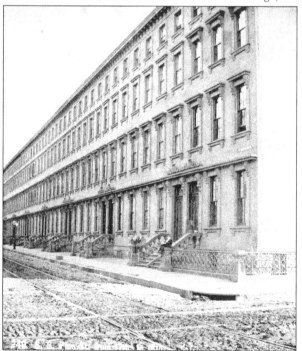

One of the earliest speculative rows constructed west of Broad Street, this block of four-story, Italianate row houses on Pine Street between Seventeenth and Eighteenth Streets was built for an upper middle-class market. The vast majority of Philadelphia homes were designed by builders or developers who constructed multiple identical residences in the hopes that they would be quickly sold at a profit to eager buyers. Only the wealthiest Philadelphians could afford to commission unique architect-designed homes like those depicted on the opposite page.

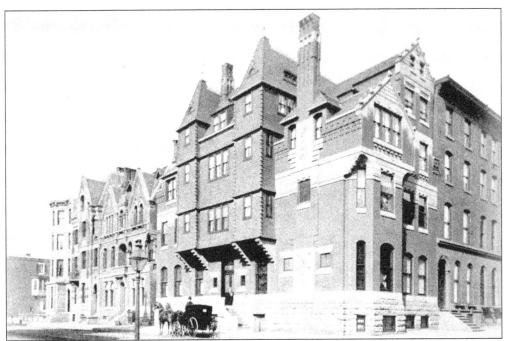

In the early 1880s, Philadelphia architect Frank Furness designed this unusual Philadelphia residence, located at the northeast corner of Twenty-second and Walnut Streets, for George B. Preston, a businessman based in New Orleans. Furness combined architectural elements and materials in daring and unconventional ways. The overhanging portion above the entryway was covered in bright red tiles, while the chimney featured insets of sandstone decorations carved with trailing vines.

Clarence Bloomfield Moore, a wealthy merchant and amateur archaeologist, commissioned this eclectic Gothic residence at 1321 Locust Street in 1890. Designed by Wilson Eyre, this house, like the one above, reflects an increasing emphasis on innovation and the combination of different styles in residential design toward the close of the century. The building has served as the headquarters of the National Union of Hospital and Health Care Employees since 1979.

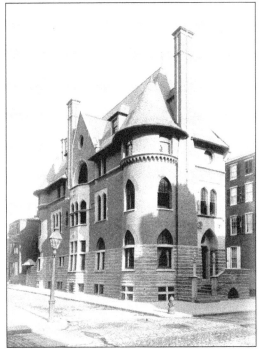

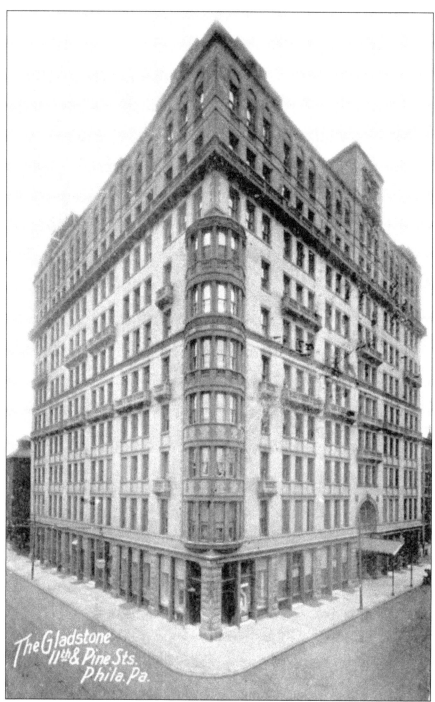

Philadelphia's first high-rise apartment building, the Gladstone at Eleventh and Pine Streets was constructed between 1889 and 1890 after the designs of Theophilus Chandler. The 10-story, steel-framed building served as a luxury-class residence for Philadelphia's elite. Dozens of apartment buildings were constructed in the city in the following decades, transforming Philadelphia's residential spaces and the built environment as the city began to grow vertically.

# *Three*

# RELIGIOUS INSTITUTIONS

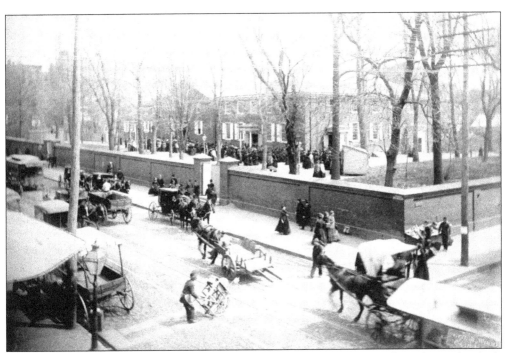

Built between 1803 and 1805 following the Quaker ideals of plainness and simplicity, the Arch Street Meeting House at Fourth and Arch Streets stands today as the largest Friends meetinghouse in the world. Designed by Quaker master carpenter Owen Biddle, the meetinghouse serves as a place for worship and as the site for local Society of Friends Yearly Meetings. Amateur Quaker photographer George Bacon Wood photographed this prominent structure in 1885 as throngs of Friends gathered at the meetinghouse entrances for the Quaker service of silence and personal reflection, as the hustle and bustle of wagons, carriages, street vendors, and pedestrians continued outside.

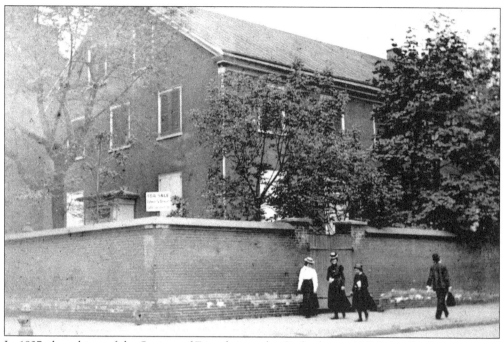

In 1827, the schism of the Society of Friends into the Orthodox and Hicksite Quakers occurred following a theological division provoked by minister Elias Hicks over the role of scripture within the faith. The Hicksites, who believed that the "inner light" of God was a higher authority than the Bible, formed their own meetinghouses such as this one, built in 1833, at the northeast corner of Ninth and Spruce Streets. In 1900, a year after this photograph was taken, the vacant meetinghouse was razed because most of the Quaker community then lived outside of the city.

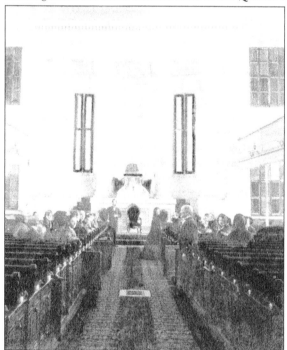

The Reverend John Chambers, visible here at his pulpit at the First Independent Church about 1860, is remembered as one of the most prominent Presbyterian ministers of the 19th century. Initially a rector at the Ninth Church, Chambers split from the Presbyterian Church when he was unable to assent to all the Puritan-influenced doctrines of the Westminster Confession of Faith (1647) required for ordination. Consequently, he and his devoted followers built the First Independent in 1831 at Broad and Sansom Streets. In 1873, the congregation was readmitted to the Presbyterian Church and the First Independent was renamed Chambers Presbyterian Church.

Known as the Nation's Church, Christ Church, established in 1695, served as a place of worship for such historically prominent figures as John Penn, George Washington, and Benjamin Franklin. Built between 1727 and 1744 at 22–34 North Second Street, this c. 1870 interior view of the Episcopal church, which has become so closely associated with the founding of the country, shows the chancel adorned with some of the most treasured relics of the sanctuary. Visible are the wineglass pulpit built in 1769 by cabinetmaker John Folwell, the 24-branch chandelier imported from England in 1744, and the Palladian windows, some of the earliest installed in an American structure.

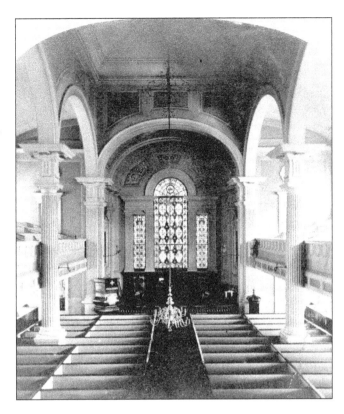

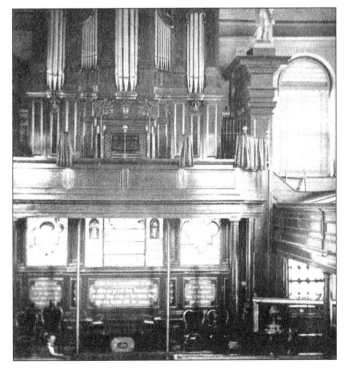

This 1860 view of the organ loft and altar, without a pulpit, at the east end of St. Peter's Church exemplifies the Episcopal church's unique design. With the placement of the pulpit at the west end, parishioners would need to alternately face each side of the church during services. Built between 1758 and 1761 after the designs of Philadelphia architect Robert Smith, the church, at 300–340 Pine Street, was formed from an overflow of congregants who worshiped at Christ Church. The third organ loft constructed for the space, installed in 1855, obscures the stained-glass windows, installed in the 1840s.

35

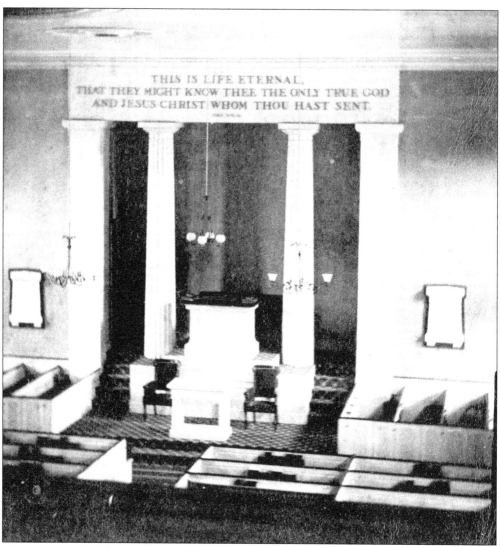

THIS IS LIFE ETERNAL,
THAT THEY MIGHT KNOW THEE THE ONLY TRUE GOD
AND JESUS CHRIST WHOM THOU HAST SENT.

Sixteen years after the organization of the First Unitarian Society in Philadelphia in 1796, the First Unitarian Church was built at Tenth and Locust Streets. By 1828, with a larger membership under the ministry of the Reverend William Henry Furness, a second edifice, depicted here in 1861, was built after the designs of Philadelphia architect William Strickland. The Bible passage on the frieze over the altar expresses the Unitarian belief that Jesus was not part of a divine trinity, but rather a human religious leader and exemplar. The church was demolished in 1885 following the construction of a larger building on the 2100 block of Chestnut Street by the reverend's son, architect Frank Furness.

Like many of the churches built in the city in the 1700s, St. Michael's Church (the Old Lutheran Church), completed in 1748, did not survive through the 19th century. Used as a garrison by British troops during the American Revolution, the church, visible here a few years before its demolition in 1872, shows the signs of abandonment. Following the relocation of the congregation in 1870, the church was razed from the 100 block of North Fifth Street.

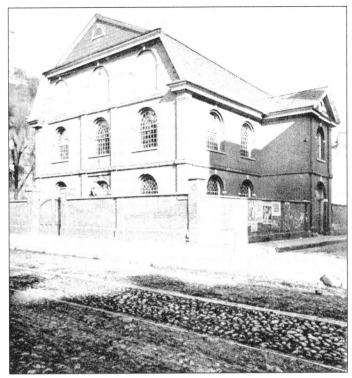

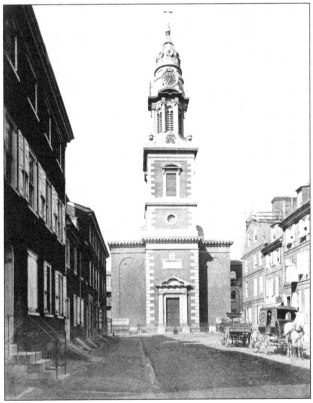

This c. 1870 view shows the second edifice of St. Augustine's Church at 260–262 North Fourth Street. Built between 1848 and 1849 after the designs of Napoleon Le Brun, the church replaced the previous structure destroyed during the anti-Catholic Nativist Riots of 1844. A successful suit filed by the Friars of St. Augustine against the city, citing freedom of religion under the Constitution, provided the funds to build this Roman-Palatine–style church. The St. Augustine's congregation, founded in 1796, was known for its benevolent organizations, including temperance and literary societies.

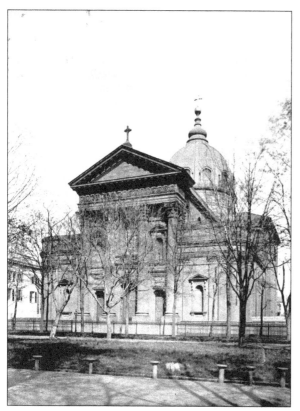

As the architecture of older churches faded from the city streets during the mid-19th century, magnificent religious structures of different styles emerged. Decades after the founding of the diocese of Philadelphia in 1808, the Cathedral Basilica of SS. Peter and Paul was built on the east side of Logan Square. The cathedral, built between 1846 and 1864, was modeled after the Roman-Corinthian style of the Lombard Church of St. Charles in Rome. Erected after the designs of Fathers Mariano Maller and John Tornatore and Philadelphia architects Napoleon Le Brun and John Notman, the cathedral incorporated clerestory windows rather than side windows in response to the city's anti-Catholic riots of 1844. The four stone Corinthian columns at the entrance and the massive copper dome distinguish the cathedral as well. The cathedral became the mother church of the Archdiocese of Philadelphia in 1875.

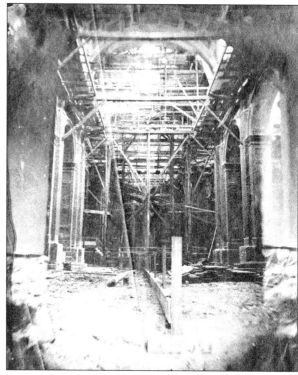

St. Stephen's Church represents another magnificent church structure added to the cityscape of Philadelphia during the 19th century. Built between 1822 and 1823 at 19 South Tenth Street after the designs of Philadelphia architect William Strickland, the Gothic-style Episcopal church houses two monuments bequeathed by devout parishioner and lawyer Edward Shippen Burd. The lower view shows one of the monuments, Burd's tomb, designed by architect Frank Wills and installed after Burd's death in 1848. The exterior view shows the construction site opposite the church for the Franklin Market, begun in 1859.

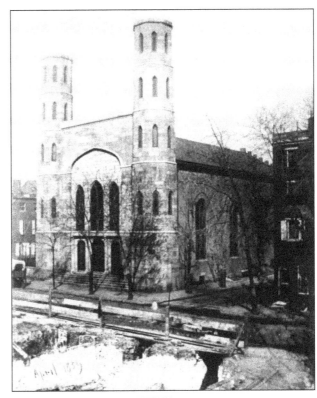

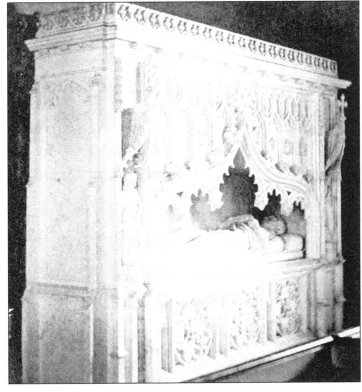

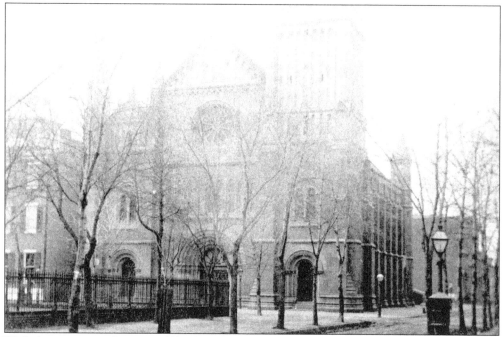

With the migration of upper middle-class Philadelphians west of Broad Street during the mid-19th century came the development of the Rittenhouse Square area. Built between 1856 and 1859 at 200 South Nineteenth Street, Holy Trinity Church, photographed here in December 1860, housed the wealthiest congregation in the city. The northwest corner of Rittenhouse Square is visible in front of the Norman-style Episcopal church completed after the designs of Philadelphia architect John Notman.

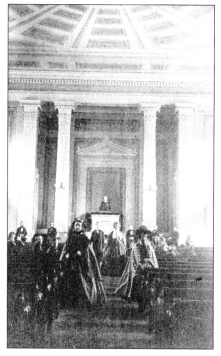

From the early 18th century, Philadelphia served as a religious center for the American Baptist Church. This 1861 view shows the congregation of the Tabernacle Baptist Church that was constituted in 1848. The posed parishioners were just a few of the 1,000 persons able to worship at the church, built in 1853 after the designs of New England architect William Boyington. Also visible is the Reverend William T. Brantly, standing at his pulpit in the background. When built, the church, located on the 1800 block of Chestnut Street, was the only Baptist church situated west of Broad Street.

This simple church, photographed in May 1859, stood at the corner of Fifth and St. James Streets. Formed in response to the discriminatory practices of the city's congregations, St. Thomas African Church was established in 1794 as the first African Episcopal church in the United States. An outgrowth of the religious and benevolent organization the Free African Society, established by Richard Allen and Absalom Jones, the church served as a religious pillar of the elite African American community during the 19th century. Jones, a freed slave, became rector in 1796.

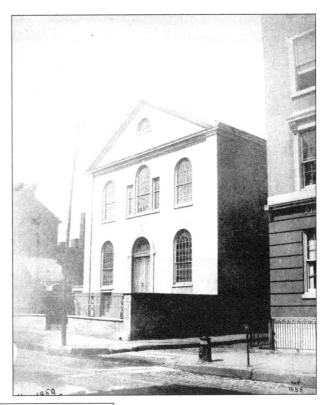

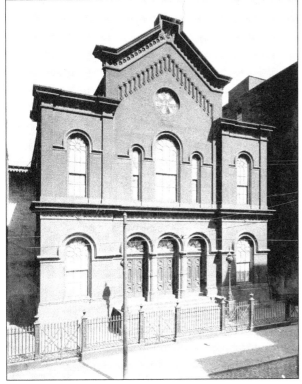

Philanthropist Rebecca Gratz, religious leader Isaac Lesser, and abolitionist lawyer Moses Dropsie were just a few of the prominent members of Philadelphia's Jewish community to worship at Mikveh Israel during the 19th century. Completed in 1860 to accommodate a growing congregation established around 1740, this third building, erected at 117 North Seventh Street after the designs of Philadelphia architect John McArthur Jr., served as the synagogue of Mikveh Israel until 1909.

41

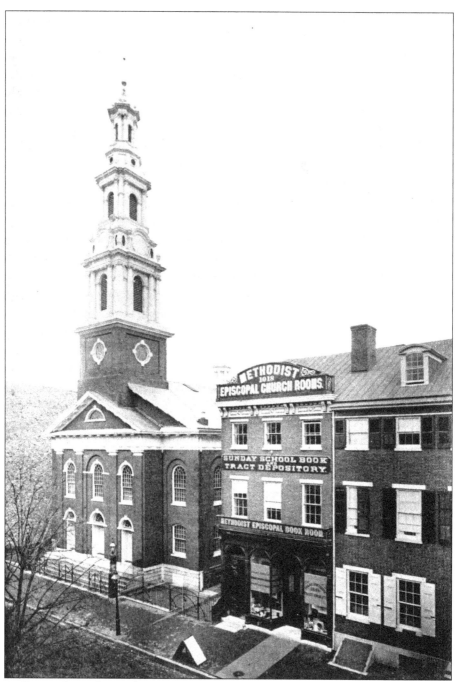

This 1869 view shows the Methodist Episcopal Book Room at 1018 Arch Street. The Conference Tract Society, established by the Philadelphia Conference in 1860, purchased the building in 1866 because it required a larger, dedicated space to support its sizeable number of religious subscriptions. While the lower rooms served as a bookstore, the upper rooms housed a bishop's office, the historical society, and a public hall used for preachers' meetings and by other Methodist associations. To the left of the book room stands not a Methodist church, but the Arch Street Presbyterian Church, originally built in 1823 as the Fifth Presbyterian Church.

The Seventh Presbyterian Church, the main site of public meetings in the Presbyterian community, was located on Broad Street above Chestnut Street. Built in 1842 after the designs of Philadelphia architect Napoleon Le Brun, the Classical-style church housed a congregation founded in 1804 by English Independents. In 1884, 23 years after this photograph was taken, the congregation, reconstituted as the Tabernacle Church, held its last service at the site before relocating to Thirty-seventh and Chestnut Streets.

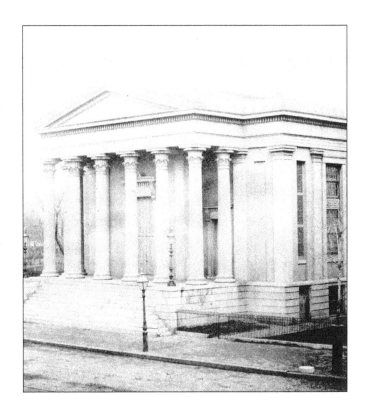

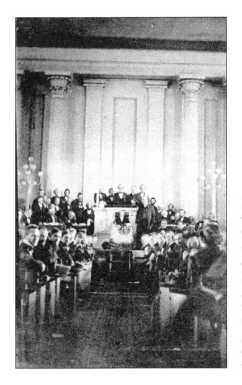

In May 1861, at the dawn of the Civil War, the General Assembly of the Old School Presbyterian Church gathered at the Seventh Church for its annual meeting. The meeting, a venue to address common concerns, was to be the last of a united Presbyterian Church in the U.S.A. for 122 years. As a result of the passage of the Gardner Springs resolution, which required pastors and church members to swear political allegiance to the federal government, the Southern congregations of the church formed the Presbyterian Church in the Confederate States of America.

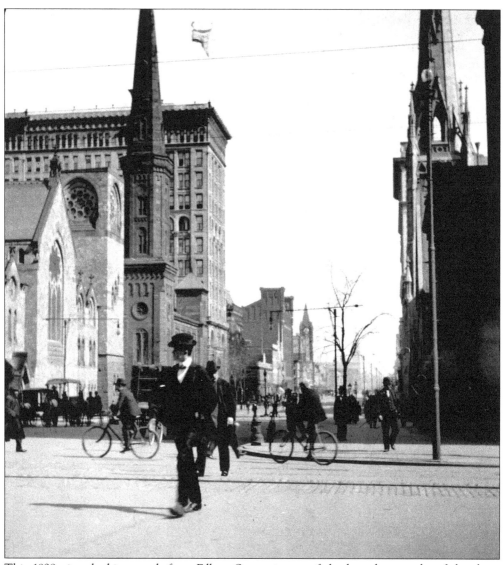

This 1898 view, looking north from Filbert Street, is one of the last photographs of the three churches at Arch and Broad Streets. Within the year, the First Baptist Church (center left), built in 1856 after the designs of Stephen Button, would be demolished, and within the decade, the Lutheran Church of the Holy Communion (far left), built between 1870 and 1875, would meet the same fate. The congregations would move farther west in the city, pushed out by the commercial growth of the area as represented by the Fidelity Mutual Life Insurance Company building (upper center). Soon to be lost from the city landscape were the Lutheran church designed by Frazer, Furness and Hewitt and the Baptist church, one of the earliest nonindustrial landmarks to grace North Broad Street. The prominent Arch Street Methodist Episcopal Church, built between 1869 and 1870 after the designs of Addison Hutton, is visible to the right. It still stands in the 21st century despite several attempts to purchase its highly valuable property.

*Four*

# BENEVOLENT
# INSTITUTIONS

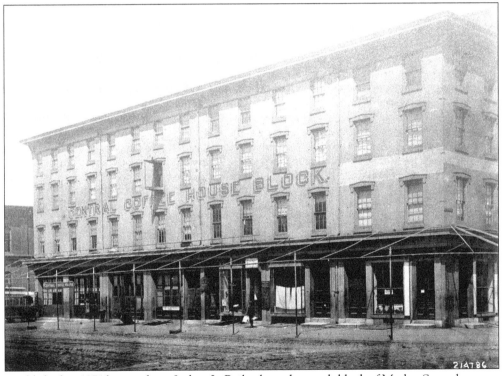

Established in 1874 by merchant Joshua L. Baily along the north block of Market Street between Merrick and Fifteenth Streets, the Central Coffee House provided working men and women with quality food at reasonable prices. Weekly prayer and temperance meetings were held there, and a free reading room was available to men. The block was demolished in 1892 to accommodate the southward expansion of Broad Street Station.

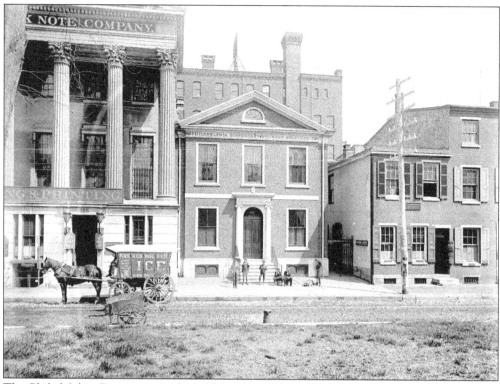

The Philadelphia Dispensary is dwarfed by the adjacent Bank Note Company, formerly the Mercantile Library, in this 1887 photograph by Marriott C. Morris. Founded in 1786, the dispensary provided in-home care to the indigent sick and specialized in inoculation against smallpox. Doctors donated their time to the institution, providing medicine to patients free of charge in return for medical experience. After renting properties near Chestnut and Strawberry Streets, the dispensary constructed its own outpatient clinic at 127 South Fifth Street in 1801. The plan of the dispensary shows a "Prescribing Room," an apothecary shop, and a room for patients on the ground floor, and a manager's room, library, and three bedrooms on the second floor. The dispensary remained here until the institution was dissolved in 1922.

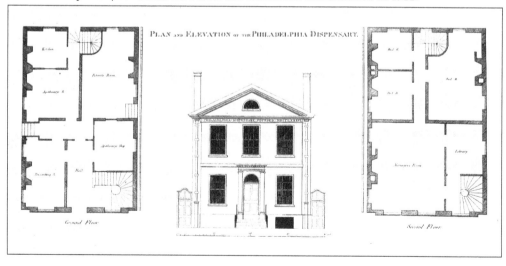

Pennsylvania Hospital, chartered in 1751 thanks to the efforts of Dr. Thomas Bond and Benjamin Franklin, served the indigent sick and mentally ill in Philadelphia. In 1756, Samuel Rhoads designed the east wing of the hospital building on the north side of Pine Street near Eighth Street. A group of men pose in front of the central administration building, built in 1804 to unite the completed east and west wings. The pilastered central block contained the oldest surgical amphitheater in the United States, the drum and dome of which are visible in this *c.* 1875 image.

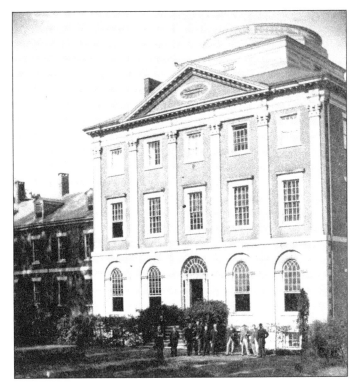

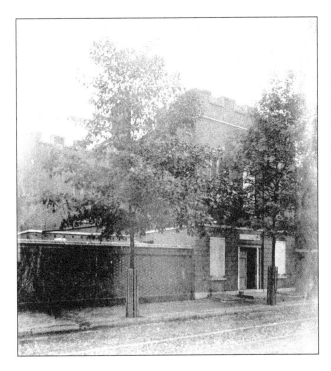

The Gothic crenellations of the T-shaped Picture House designed by Philadelphia carpenter Samuel Webb are visible despite the concealing tree foliage lining Spruce Street in this *c.* 1870 photograph. The building was erected between 1816 and 1817 at 820 Spruce Street, on the grounds of Pennsylvania Hospital to display the Benjamin West painting *Christ Healing the Sick in the Temple*, which was donated to the hospital in 1817. After the painting was removed in 1843, the College of Physicians, the Historical Society of Pennsylvania, and a nurses' dormitory separately occupied the building until its demolition in 1893.

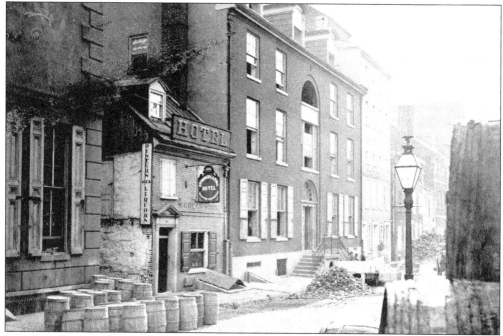

Barrels and piles of bricks from demolition clutter the 300 block of Cherry Street near the former Hospital for Poor Distressed Women, also known as Christ Church Hospital, in this *c.* 1861 image showing the block during a period of transition. The Spinners Arms and the Golden Fleece hotels flank the former charitable institution built in 1819 after designs by William Strickland. Founded in 1778 by physician and vestryman John Kearsley to aid impoverished female parishioners of Christ Church, the almshouse had already moved to its new building in West Philadelphia at the time of this photograph. Around the same time, Mikveh Israel Synagogue was being demolished along the north side of the block.

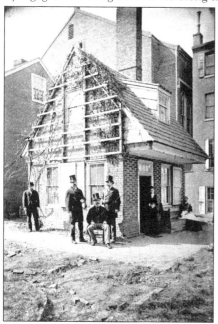

A group of men and women pose in front of the last remaining Quaker Almshouse cottage in this *c.* 1876 photograph by James Cremer. The Quaker Almshouse was the first of its kind, established in the colonies in 1713 to support needy members of the Society of Friends. Local tailor John Martin bequeathed land for the institution along Walnut Street below Fourth Street, upon which several small, one-story cottages were built and rented for profit and later used to house elderly Friends. The City Almshouse, constructed several years later in 1732, resembled its Quaker neighbor but provided shelter, employment, and a hospital for all denominations.

The Female Society of Philadelphia for the Relief and Employment of the Poor, one of the first charities in Pennsylvania established by women, was founded in 1795 under the leadership of Anne Parrish. The Quaker group provided food, clothing, and fuel to widows and children of men who had perished in the yellow fever epidemic of 1793. The society later established a House of Industry with a nursery, where women were employed to make handicrafts. The House of Industry depicted here in 1870 was located at 112 North Seventh Street. In 1916, the charity moved to 716 Catharine Street and was later known as the Catharine Street House of Industry.

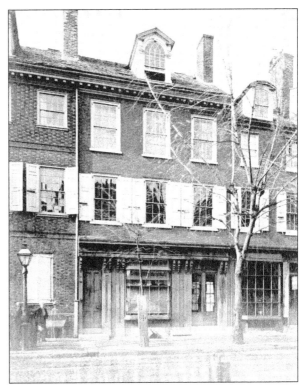

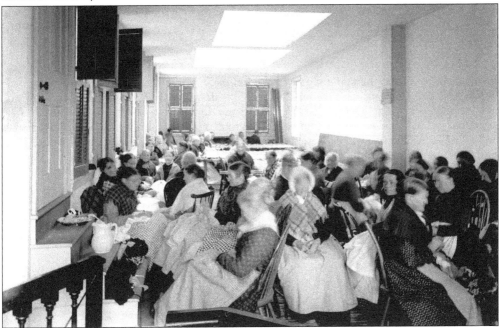

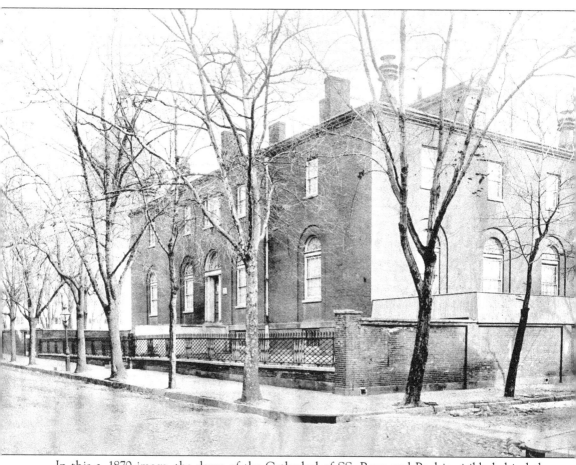

In this c. 1870 image, the dome of the Cathedral of SS. Peter and Paul is visible behind the building of the Orphans' Society of Philadelphia, designed by William Strickland, at the northeast corner of Eighteenth and Cherry Streets. Eminent philanthropist Rebecca Gratz organized the non-denominational home with a group of like-minded women to provide shelter and educate children until they were apprenticed to families. The institution moved to West Philadelphia, and the building was razed in 1872.

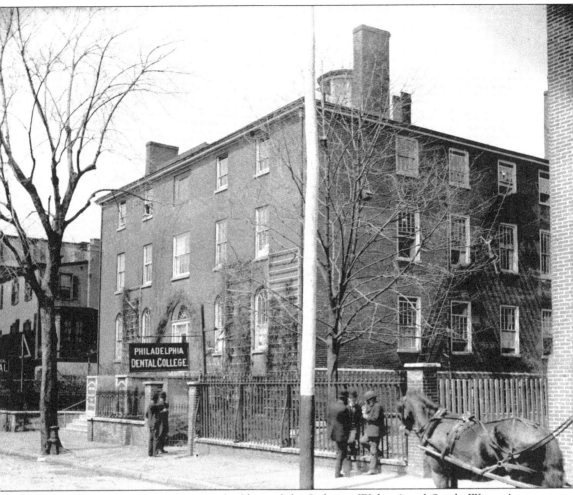

This *c.* 1890 image shows the former building of the Indigent Widows' and Single Women's Society asylum. The society was established in 1819 and its asylum constructed, after designs by William Strickland, at 1717 Cherry Street, adjacent to the orphanage operated by the Orphans' Society of Philadelphia. Single and widowed women under 60 years of age were eligible to apply for entrance into the home and were required to provide "satisfactory testimonials to the propriety of their conduct, and respectability of their character." The society moved its asylum to West Philadelphia around 1887 and the Philadelphia Dental College and Medico Chirurgical Hospital took over the site.

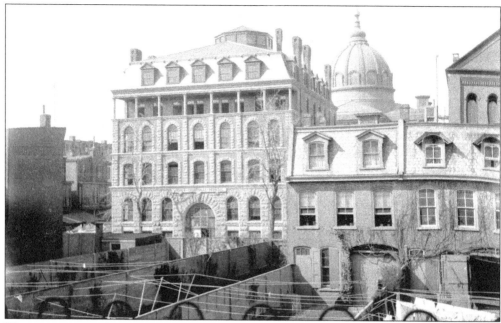

This *c.* 1890 view, photographed by George Vaux Jr., depicts the area north of his family's home at 1715 Arch Street, showing the Medico Chirurgical Hospital in the foreground and the dome of the Cathedral Basilica of SS. Peter and Paul in the background. Founded as a medical society in 1848, the Medico Chirurgical College opened its doors in 1881 at the southwest corner of Broad and Market Streets and moved to a larger campus with a hospital on the 1700 block of Cherry Street around 1887. The hospital merged with the University of Pennsylvania in 1916, and its building was demolished in May 1918 to make way for the Benjamin Franklin Parkway.

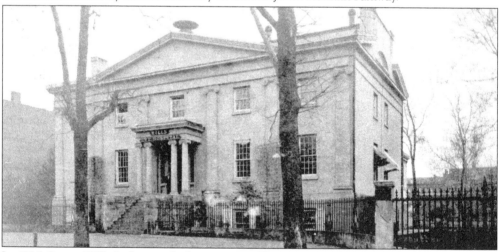

In 1825, James Wills Jr. bequeathed a portion of his estate to the city of Philadelphia for an ophthalmic hospital or asylum designated as the Wills Hospital for the Relief of the Indigent Blind and Lame. The lot on Race Street near Nineteenth Street was purchased for $20,000, and the cornerstone of the building was laid in 1832. Thomas Ustick Walter, who won the design competition, purportedly incorporated some of the design features proposed by his competitors into the final plan. In 1932, the expanded institution moved into a larger building at 1601 Spring Garden Street.

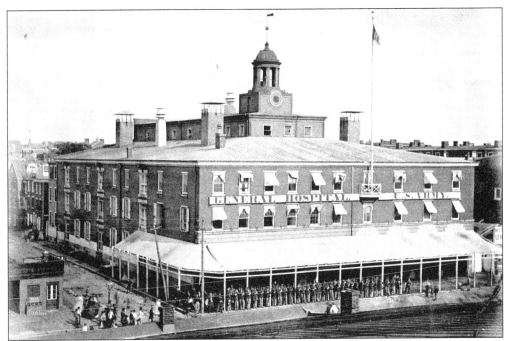

Twenty-four military hospitals operated in the city during the Civil War to care for approximately 157,000 soldiers, who were transported by rail to Philadelphia. The Broad Street Hospital at the southeast corner of Broad and Cherry Streets opened on February 2, 1862, in an old Philadelphia and Reading Railroad station and closed in January 1863 after the completion of Mower General Hospital in Chestnut Hill. It reopened briefly following the Battle of Gettysburg in July 1863.

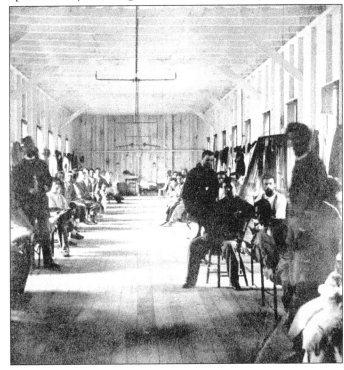

Recuperating soldiers are seated in opposite rows lining the walls of a ward in the South Street Hospital. Located at Twenty-fourth and South Streets, this Civil War hospital was sometimes referred to as "stump hospital" because of the large number of amputations performed there.

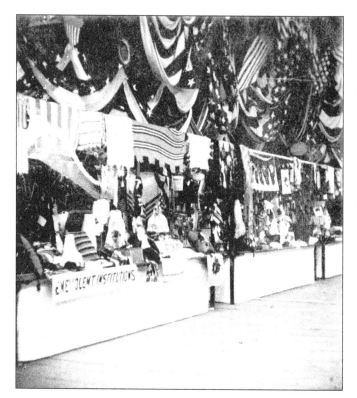

Local businesses and benevolent institutions donated products and staffed booths at the Sanitary Fair, held in Philadelphia's Logan Square in June 1861 to raise money for the benefit of Union soldiers. Displays featured the latest technology and tools, along with relics, art work, and plant specimens from all over the world.

Clara Wrigley wears a black bonnet with a large ribbon bow popularized by Evangeline Booth as part of her Salvation Army uniform in this c. 1898 portrait. The Salvation Army began as the Christian Mission, an evangelical group, founded by William and Catharine Booth, that preached the gospel of Christ and provided shelter to the poor in London's East End. The group adopted its current name and quasi-military theme in 1878. One year later, Eliza Shirley organized the first meeting in Philadelphia, marking the beginning of the Salvation Army in the United States.

# *Five*

# BUSINESS AND INDUSTRY

Market Street has long been one of the city's commercial thoroughfares. Here on the 400 block of Market Street, shoppers in the late 1860s could purchase a wide variety of goods. Dry goods and clothing shops, a hardware store, and a store selling china dinnerware all competed for consumers' attention with elaborate signs, including an anvil on the roof of the hardware store.

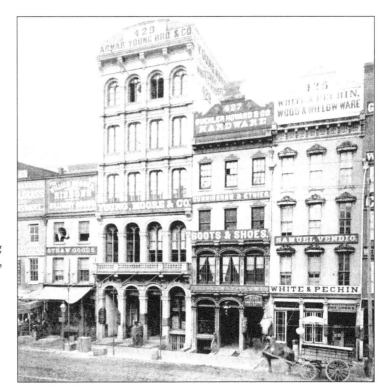

Photographer James McClees captured this view of the south side of the 600 block of Chestnut Street, showing the studio he shared with Washington Lafayette Germon, shortly before the building was destroyed by fire in March 1855. At the time, Philadelphia, a leading center of American photography, supported more than 120 photographers. Although signage on the building advertised the men as daguerreotypists, by the mid-1850s, McClees was also producing some of the earliest photographic views of Philadelphia printed on paper.

In 1836, John B. Myers and John W. Claghorn established an auction and commission merchant business and were soon joined by Claghorn's son and future partner James. This view, taken around 1860, shows the Myers, Claghorn and Company building located on the south side of Market Street between Second and Third Streets. A ramp at the front entrance facilitated easier movement of goods in and out of the building. After retiring from the business in 1861, James Claghorn worked tirelessly for the Union League and became a well-known art collector and patron of the arts.

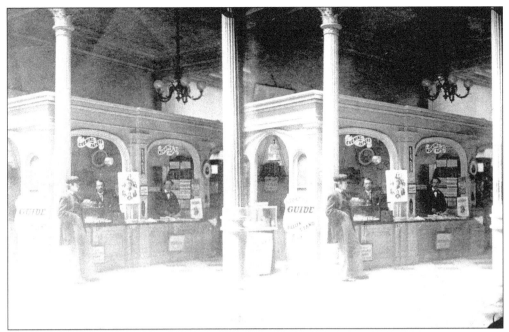

The Continental Hotel, located at the southeast corner of Ninth and Chestnut Streets, epitomized first-class accommodations for business and leisure travelers. Designed by John McArthur Jr., the hotel opened in 1860 and could house about 1,200 guests, offering them such amenities as a "vertical railway" or elevator, telegraph office, food service 18 hours a day, and elegantly appointed public and private rooms. At the newsstand, shown here soon after the hotel opened, guests could purchase newspapers, guidebooks to the city, postage stamps, and theater tickets.

The Continental Hotel rented space on its first floor to tenants including Charles Oakford and Sons' hat store. The richness of the hotel's interior extended into its commercial space with Italian marble floors and 16-foot-high frescoed ceilings visible in this early 1860s photograph. Gentlemen entered through the hotel's main lobby, while ladies used a separate entrance off Chestnut Street. Charles Oakford began manufacturing hats in Philadelphia in 1827 and by 1850, had expanded the business into the wholesale market, sending hats all over the country. Family members remained in the hat business into the 20th century.

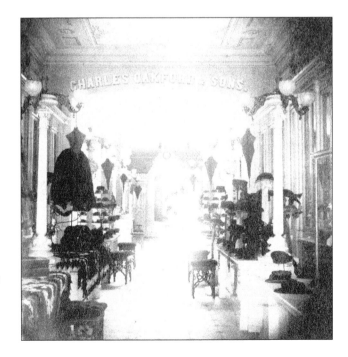

In 1816, John Struthers established one of Philadelphia's first marble yards. When this photograph was taken in the summer of 1858, John's son William ran the marble yard located at Chestnut and Twenty-second Streets. By the late 1850s, Philadelphia supported about 60 marble cutting establishments. Marble from the Struthers' business was used to construct many significant Philadelphia buildings including city hall, the Public Ledger building, the Continental Hotel, and the Second Bank of the United States.

Designed by Philadelphia architect John McArthur Jr., the Public Ledger building located at the southwest corner of Sixth and Chestnut Streets opened in June 1867, about the time this photograph was taken. From the pressroom in the basement to the composing room on the top floor, the building incorporated innovations including the largest wrought iron columns ever made, each able to support 330 tons. The lightning rod held by the Benjamin Franklin statue on the building's exterior was even designed to emit gas-lit flames at night.

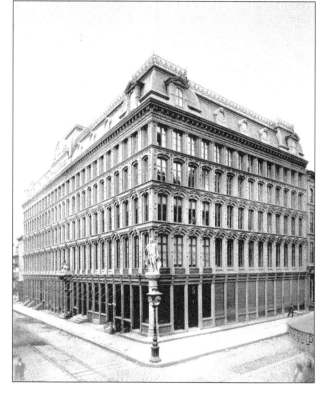

Not all Philadelphia hotels were grand like the Continental, as seen in this c. 1885 view of the 7th Ward Central Hotel located at 1300 Lombard Street. The availability of beer and ale seems to be this hotel's major attraction. In the late 19th century, the Seventh Ward contained the city's largest concentration of African Americans, including both the homes of the city's black elite as well as slums. The Seventh Ward was the focus of W. E. B. DuBois' famous sociological study, *The Philadelphia Negro* (1899).

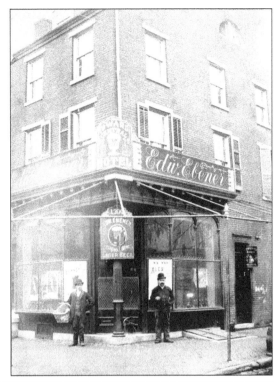

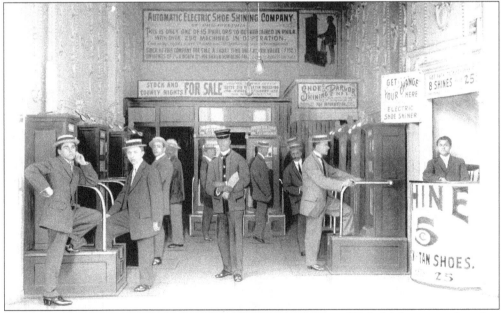

About 1900, the Automatic Electric Shoe Shining Company of Philadelphia opened its first parlor on the north side of the 1300 block of Market Street. For a nickel, customers could enjoy the latest technological wonder, a machine designed to shine either black or tan shoes. The African American attendant standing in the center of this c. 1900 photograph holding a rag probably buffed the customers' shoes. According to the large advertisement above the door, the company planned to open 15 parlors in Philadelphia.

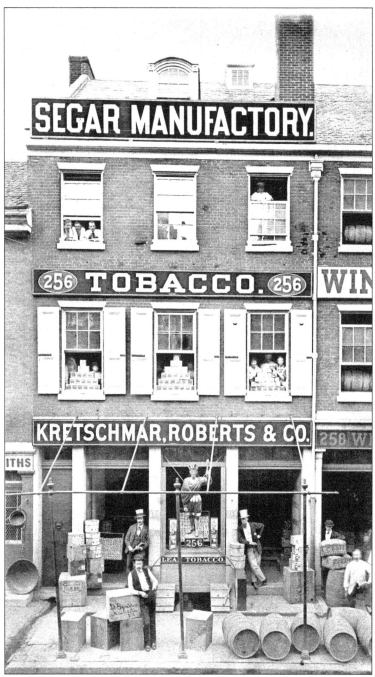

The short-lived partnership of Frederick Kretschmar, Charles Roberts, and Herman Uth was documented in this early 1870s photograph showing their cigar manufacturing business on the 200 block of North Third Street. Most late-19th-century cigar manufacturers employed only a few workers, but when the workforce grew to more than about 10, labor was usually split into departments and segregated by sex, with women performing the less skilled, low paying jobs, such as stripping away the midrib of the tobacco leaf. At this cigar manufactory, the employees, including men, women, and boys, pause in their work to pose for the photographer.

Men dominated the business world in the 19th century, but it was not uncommon for women to own small specialty shops. This early 1870s view shows Mary A. Binder's trimmings store located at the northwest corner of Eleventh and Chestnut Streets. Here customers could purchase paper patterns, dress and cloak trimmings, laces, and embroideries imported from Paris and London. Mary Binder had been in business at other Philadelphia sites for about 10 years prior to moving to this prime corner location in about 1870.

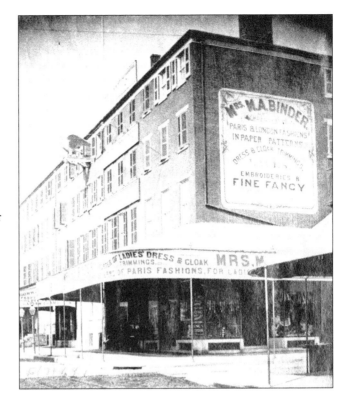

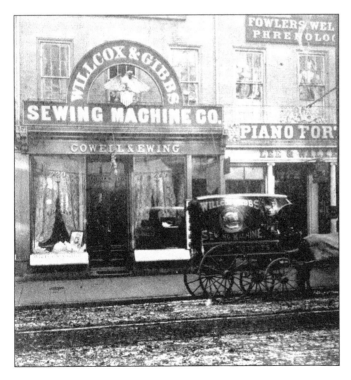

Virginia inventor James Gibbs and Philadelphia investor James Willcox joined forces in 1859 to manufacture sewing machines. Considered technological wonders, domestic sewing machines drastically reduced the amount of time women spent making and repairing clothes for their families. In 1867, about the time this photograph was taken, Willcox and Gibbs produced 14,000 machines. Willcox and Gibbs sewing machines purchased at the 720 Chestnut Street store of Henry Cowell and Daniel Ewing would have been delivered via the wagon parked in front.

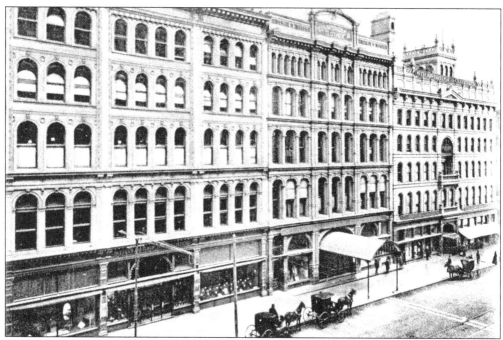

In 1861, with $2,500 in capital, Justus Strawbridge opened a dry goods store at the northwest corner of Market and Eighth Streets. In 1868, another young Quaker Isaac Clothier joined him, and together they prospered selling good quality domestic and imported dry goods. The business continually expanded until by the time of this early 20th-century postcard the store took up almost the entire block. In the 1890s, the shop became a department store, selling a variety of products including clothing, furniture, bicycles, books, and candy.

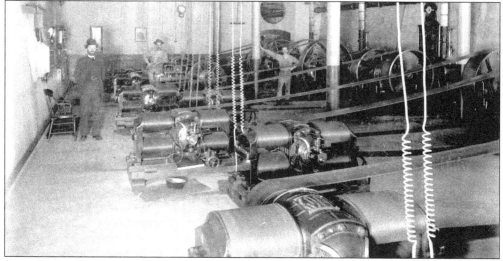

Around 1887, Strawbridge and Clothier relocated its engine room from the store basement to the basement of its newly constructed stable across the street on the north side of the 800 block of Filbert Street. The new equipment generated power for the store's more than 2,000 lamps, making it Philadelphia's largest private electric plant. In this 1888 image, plant superintendent Daniel Crosby, who lived on the stable's third floor, stands proudly near the equipment with two of his workers.

In the 1850s, Philadelphia antiquarian Charles A. Poulson commissioned artist and photographer Frederick DeBourg Richards to photographically document the city's disappearing 18th-century architectural landscape. This image, one of approximately 120 views shot by Richards, was taken in April 1859, only days before the demolition of this building at the northwest corner of Seventh and Chestnut Streets. The building's last tenants included a wine shop, a piano store, and on the top story a shooting gallery with bulls-eye targets affixed to the windows.

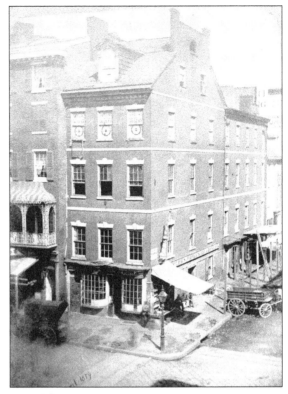

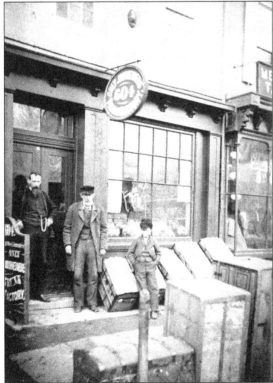

Three generations of the Carson family stood in front of their trunk factory at 604 Race Street in this c. 1885 photograph. A fire mark above their display window indicated that the property was insured, possibly by the Reliance Insurance Company. John Carson and his son Andrew established a trunk manufactory at this location about 1870 and remained here for the next 20 years. At the time of this photograph, the city supported about 30 trunk manufactories, employing just over 200 people.

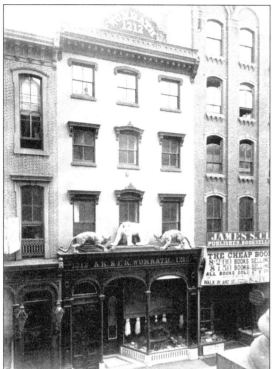

Brothers Frederick and Andrew Womrath moved the family furrier business to 1212 Chestnut Street in 1869, a few years before this photograph was taken. The polar bear, tiger, and leopard sculptures seen above the front entrance came with them from their earlier building. By 1875, the Womrath firm had relocated back to Arch Street, an area where many fur dealers and furrier businesses were clustered.

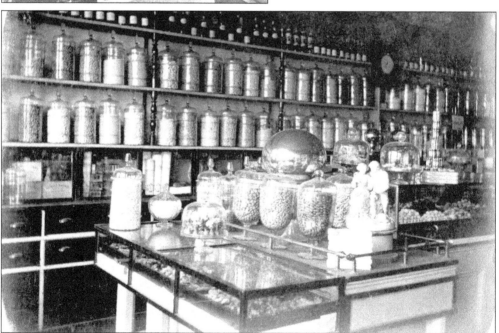

In 1866, Stephen Whitman moved his confectionery business from Third and Market Streets to a four-story building at Twelfth and Market Streets and equipped it with machinery imported from France. A steam boiler in the basement powered chocolate grinders and other equipment. The salesroom occupied the building's first floor. This c. 1871 photograph shows Whitman's shop interior filled with a tempting array of hard candy, sugar-coated nuts, and bonbons.

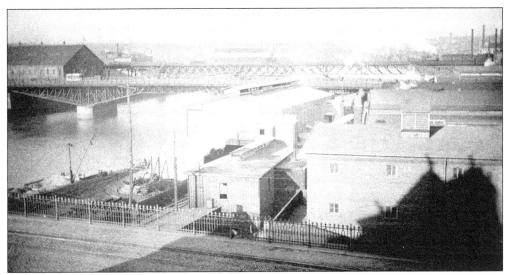

Looking north from an upper-story window of the Baltimore and Ohio Railroad Station located at Chestnut and Twenty-fourth Streets, this 1891 photograph shows the city's industrial waterfront along the Schuylkill River, including parts of the Philadelphia Gas Works and a freight depot. Horse-drawn vehicles and a train travel across the numerous bridges spanning the river in the background.

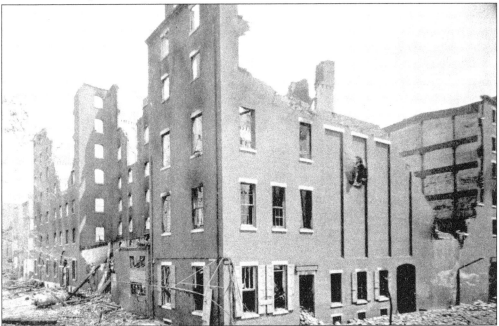

On the evening of January 4, 1874, fire swept through the north building of McKean, Newhall and Borie's Sugar Refinery on Lagrange Place, between Second and Third Streets south of Arch Street. For three hours, firefighters fought the blaze from the roof of another structure on the property and kept the fire from spreading to the building where expensive equipment and a valuable stockpile of sugar were kept. The company, nevertheless, experienced a $200,000 loss from the fire. This refinery, one of thirteen in the city in 1870, helped make Philadelphia a leading sugar refining city in America in the late 19th century.

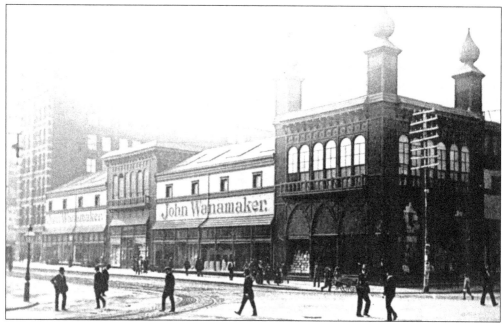

Having outgrown his original men's and boy's clothing store at Sixth and Market Streets, John Wanamaker purchased an abandoned Pennsylvania Railroad freight depot at Thirteenth and Market Streets in 1874 and remodeled it into Philadelphia's first department store. Known as the Grand Depot, the store attracted thousands of customers daily. By the time of this 1896 photograph, the store had electric lights, telephones, elevators, a large restaurant, and "many waiting, reading and toilet rooms" for the comfort of the customers. In the early 20th century, a new Wanamaker's store was constructed on the same site.

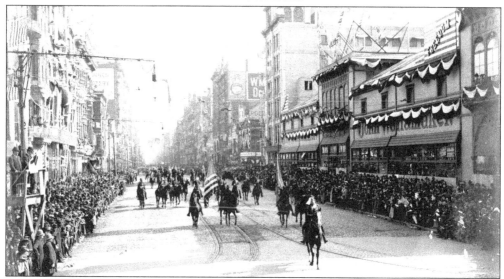

Thousands thronged the sidewalks while others leaned from balconies as a parade celebrating the end of the Spanish-American War passed through Philadelphia's commercial district on the 1300 block of Market Street. Philadelphia's patriotic fever burned brightly during the three-day celebration in late October 1898. Flags, bunting, and signs covered the building facades along the parade route, including John Wanamaker's Grand Depot in the foreground.

## *Six*

# URBAN TRANSIT

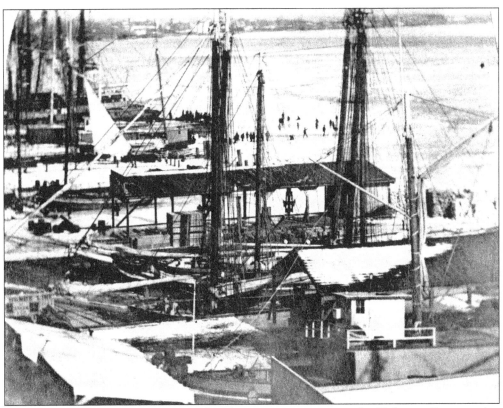

Mother Nature suspended commercial and passenger activity on the Delaware River in this *c.* 1860 winter image. Bare-masted schooners and small boats are docked along the snow-covered piers of Philadelphia harbor in the foreground as people ice-skate on the frozen river in the background. Ice-skating was a common activity on the impenetrable river before the use of steam-powered icebreakers. Organizations such as the Philadelphia Skating Club and Humane Society provided skating instruction and rescued people who broke through the ice.

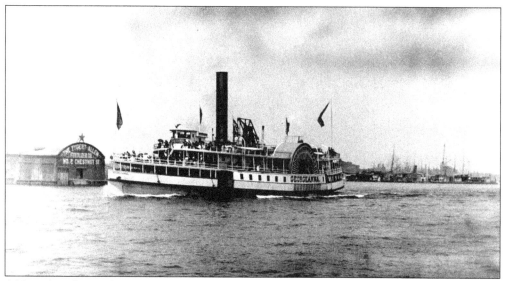

Although Robert Fulton is often credited as the founder of the first successful steamboat service in 1807, John Fitch constructed a steamboat tested in a trial run on the Delaware River in 1787. Fitch kept improving his design and within two years built two steamboats that operated between Philadelphia and Burlington, New Jersey. The *Georgeanna*, seen here on the Delaware River, was built in 1859 by Harlan and Hollingsworth in Wilmington, Delaware, and was purchased in 1860 by the Baltimore Steam Packet Company. The first iron-hulled steamboat used regularly by the company, the ship was sold in 1869.

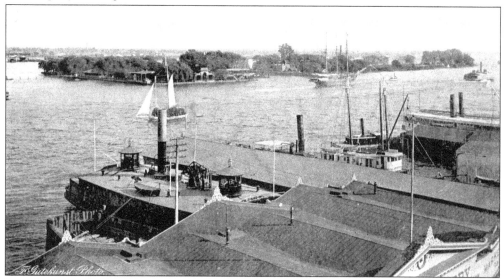

Ferry boats, including the *Arctic*, are docked at the Market Street ferry terminal while other vessels navigate the water near Smith and Windmill Islands in the Delaware River in this *c.* 1890 view. Smith Island to the north and Windmill Island to the south served as summer resort areas throughout most of the 19th century, offering an amusement park, hotel, bath house, restaurant, beer garden, and music. Small steamboats transported passengers from Chestnut and Walnut Street wharves to the islands every 10 minutes. In 1838, a channel was cut through Windmill Island to improve ferry navigation between Philadelphia and Camden, New Jersey. Both islands were removed by 1897.

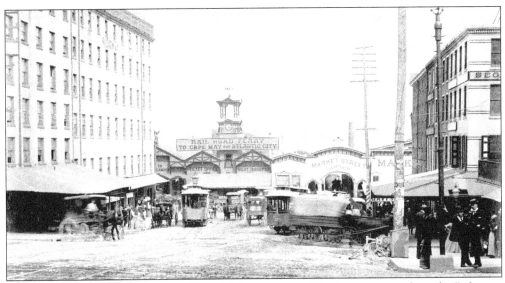

Ferries transported passengers from Philadelphia to various New Jersey towns along the Delaware River until 1952, long after the completion of the Benjamin Franklin Bridge in 1926. Prior to the opening of the Pennsylvania Railroad's service to New York City in 1867, travelers relied on the ferries from Philadelphia to connect with the Camden and Amboy Railroad in New Jersey. The custom of naming a ferry service after its owner changed when the ferries were adopted by the railroads, such as the Pennsylvania Railroad's Market Street ferry terminal, depicted here in 1889, nine years before the railroad reconstructed the slips and station.

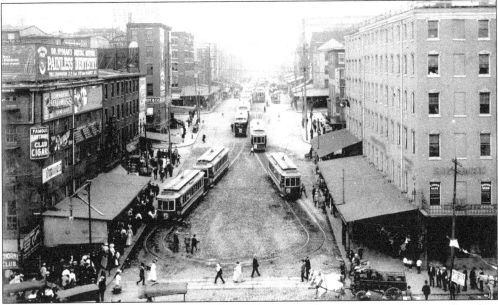

In this c. 1900 view looking west from the Market Street ferry terminal, electric trolleys line Market Street in the distance and pedestrians walk alongside horse-drawn carriages and carts near the trolley loop at Delaware Avenue. The City Railroad transit line, the first constructed along Market Street in 1838, ran east from Broad Street to the business district and further congested an already busy road lined with market stalls. Even after the removal of the City Railroad around 1870, Market Street remained a main mass transit artery.

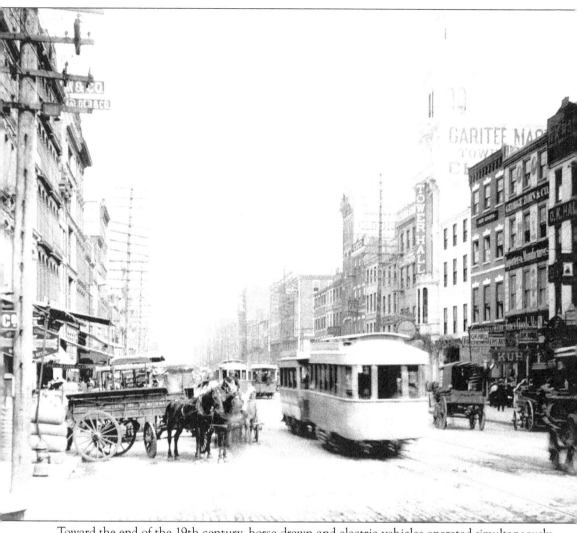

Toward the end of the 19th century, horse-drawn and electric vehicles operated simultaneously on Philadelphia's streets, as demonstrated in this dynamic view of carriages and carts riding side-by-side with railway vehicles on the 500 block of Market Street.

Demolition is underway, as shown in the right-hand image by a few empty, brick-covered lots next to dilapidated buildings on North Twelfth Street between Market and Cuthbert Streets. The rear of the Butchers' and Farmers' Market and the Franklin Market are visible on Filbert Street. These markets were demolished in 1892 for the erection of the Philadelphia and Reading Railroad Company terminal and market, built between 1891 and 1893. The Reading's Broad and Callowhill station could no longer compete with the location or passenger capacity of the Pennsylvania Railroad's Broad Street Station, so despite its financial woes, the Reading built a new station that would allow the railroad to direct all lines into one terminal. Seen below is the skeleton of the train shed next to the Butchers' and Farmers' Market around 1890.

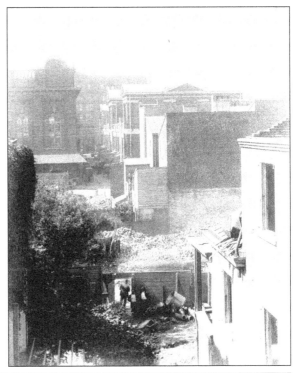

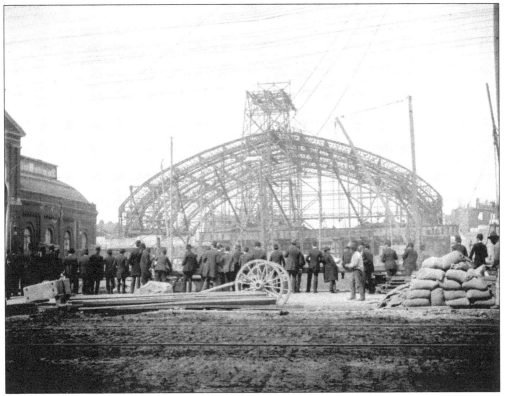

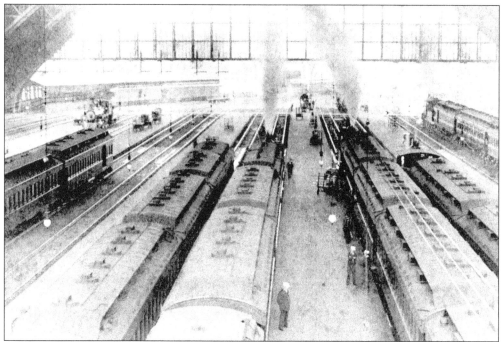

Locomotives are lined up in the Reading Railroad's elevated train shed, which received trains from a north-south viaduct constructed between Eleventh and Twelfth Streets. The single-span shed with a width of 266 feet and height of 88 feet could accommodate 13 steam engines and was the largest in the world when it was constructed by Wilson Brothers and Company between 1891 and 1893.

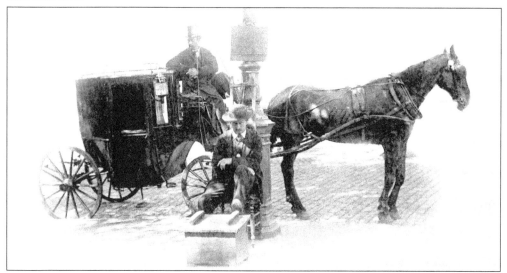

In the early 19th-century city, most people moved about on foot or, if they were wealthy enough, rode in privately owned horse-drawn carriages. Hackney carriages were available for hire and often waited outside of hotels to transport passengers from Center City to outlying train and ferry terminals. In this image, two cabbies and a horse-drawn coach are parked outside of the Continental Hotel at Ninth and Chestnut Streets. The development of omnibus lines in the 1830s and horsecar lines in the late 1850s marked the beginning of mass transit systems in Philadelphia.

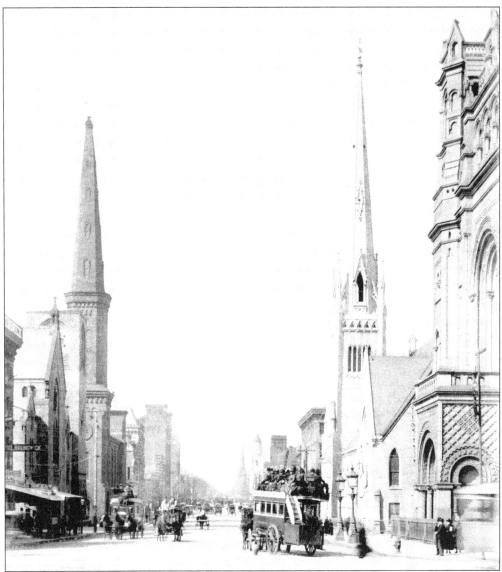

Horse-drawn omnibus services began in Philadelphia in 1833. The omnibus resembled a boxy, brightly painted stagecoach with about 12 to 20 seats. Originally heralded as a milestone in mass transit, the omnibus quickly received negative criticism for its overcrowded, noisy, and bumpy conditions. In this image, a crowded double-decker omnibus pulled by three horses travels north along Broad Street from Penn Square. The double-decker service began along this route in 1890, but the weight of the buses and the unyielding granite paved street put a strain on the horses, and the bus service was discontinued a few years later.

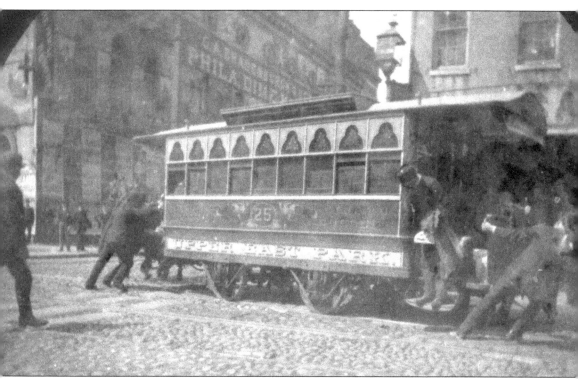

Unlike omnibuses, horsecars rode on flanged wheels on iron rails, producing a smoother, faster ride (six to eight miles per hour) and could accommodate almost twice the number of passengers. The first horse railway service in Philadelphia began in 1858. Although an improvement over the omnibus, track installation and street maintenance inconvenienced everyone using Philadelphia's streets. The horsecar also relied too heavily on overworked, disease-susceptible horses pulling overcrowded cars. When they got stuck, manpower was necessary to complete a turn, as seen in this c. 1890 image of an Upper East Park car at Ninth and Arch Streets.

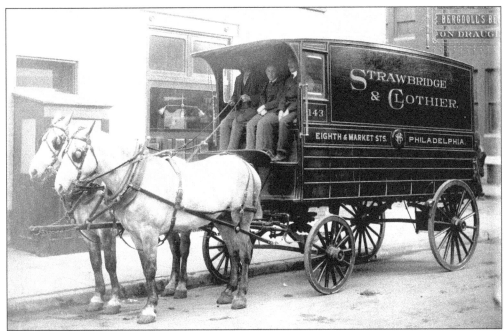

Department stores thrived near the new transit routes in the downtown area. Their horse-drawn delivery wagons were a common sight next to the horsecars and electrified streetcars at the end of the 19th century. Three uniformed deliverymen sit inside this green Strawbridge and Clothier delivery wagon, drawn by two dapple gray horses outside of the company's stables at Eighth and Race Streets. Theodore Grass's beer saloon is visible in the background.

Timothy Palmer designed the Market Street Permanent Bridge, a covered wooden wagon bridge flanked by pedestrian walkways over the Schuylkill River. The cornerstone was laid in 1800, and the bridge was completed in 1806. It was expanded around 1850 to carry the tracks of the Philadelphia and Columbia Railroad into the Center City area to connect with the City Railroad. A leaky gas main caused a fire that destroyed the bridge in 1875, about five years after this image was taken.

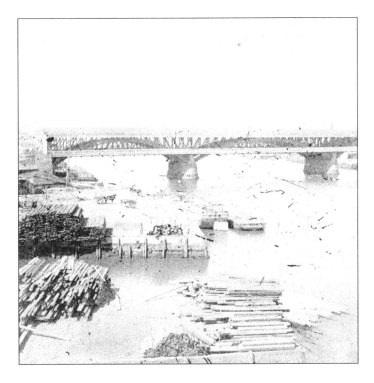

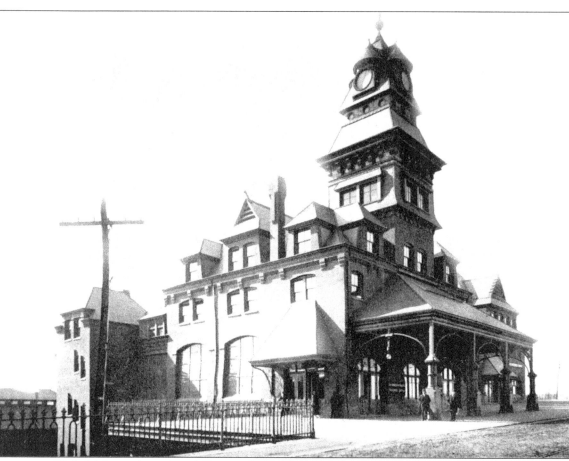

Philadelphia architect Frank Furness designed three railroad stations for the Baltimore and Ohio (B&O) Railroad, including the Philadelphia depot constructed between 1886 and 1888 at the southeast corner of Twenty-fourth and Chestnut Streets. The Schuylkill East Side Railroad, a line chartered by the B&O with the Reading Railroad, ran south from Fairmount along the east side of the Schuylkill River, connected with the new terminal, and continued south to Baltimore and Washington, D.C. Both railroad companies wanted to compete with the Pennsylvania Railroad's profitable line to the capital. This photograph was part of an 1891 photographic survey of the B&O Railroad's bridges and stations between Baltimore and Philadelphia.

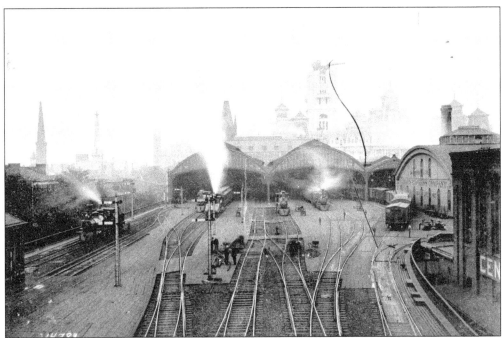

The Pennsylvania Railroad's first Broad Street train shed extended 450 feet in length from Merrick Street west to Sixteenth Street and accommodated 12 tracks underneath four separate arched sheds. When the shed was enlarged in 1893, the tracks increased to 16 and a unifying iron and glass canopy was constructed, as seen below. The tracks extended west from the train shed along an elevated brick viaduct known as the Chinese Wall, which ran between Market and Filbert Streets. The viaduct acted as both a physical and social barrier, isolating the northwest section of Center City above Market Street and stigmatizing it as an undesirable place for development.

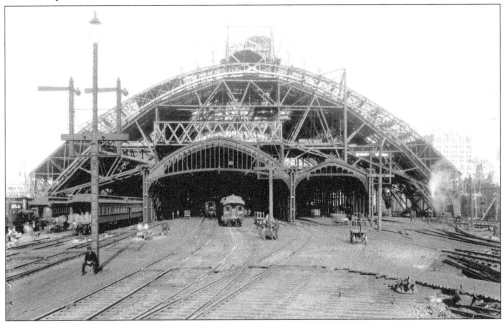

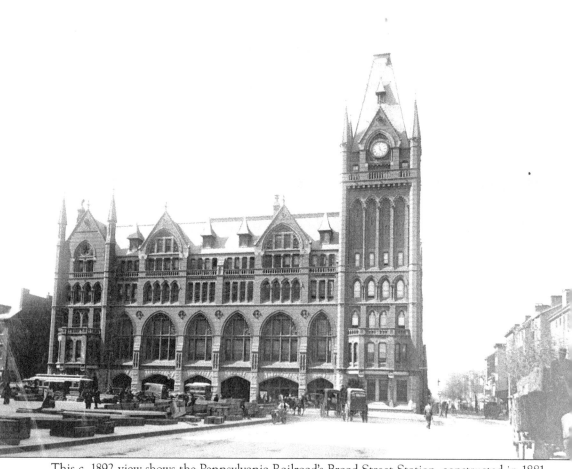

This *c.* 1892 view shows the Pennsylvania Railroad's Broad Street Station, constructed in 1881 after designs by Wilson Brothers and Company, on the west side of Penn Square. A clock tower rises on the north end of this asymmetrical Gothic "cathedral to transportation," and six unequal bays and piers create openings on the street level for carriage traffic underneath. Trains entered the second floor of the station from elevated tracks along the Chinese Wall. The addition of a 10-story office building designed by Frank Furness in 1893 extended the station south to Market Street. The magnificent Broad Street Station exemplified the train station as a new, distinct building form and symbolized the westward shift of the Center City area.

# Seven

# CLUBS AND ORGANIZATIONS

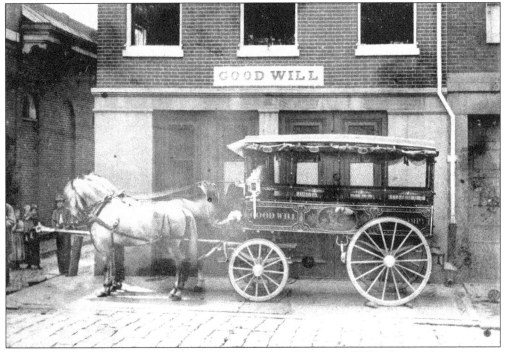

A horse-drawn ambulance stands at the ready in front of the Good Will volunteer fire company's firehouse at Juniper and Race Streets in this c. 1865 photograph. During the Civil War, Philadelphia fire companies raised money to purchase ambulances that the firefighters used to transport sick and wounded soldiers brought to the city for medical care. The volunteer fire companies, as well known for intercompany rivalry as for fighting fires, were eliminated in 1870 when the city passed an ordinance establishing a paid fire department.

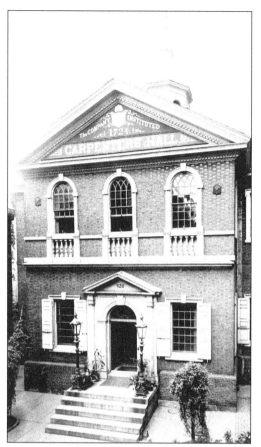

Carpenters' Hall (shown at left around 1890), home of the Carpenters' Company of the City and County of Philadelphia, was completed in 1774 south of Chestnut Street between Third and Fourth Streets. Designed by member Robert Smith, it has played a significant role in both local and national history, including serving in 1774 as the meeting site for the First Continental Congress. The Carpenters' Company, founded in 1724, is probably the oldest trade organization in the United States. Throughout its long history, the company has rented its building to numerous tenants including the Library Company of Philadelphia, the American Philosophical Society, the Bank of Pennsylvania, and the Philadelphia Customs Office. In 1857, the Carpenters' Company evicted the auction firm renting its hall and began renovations in order to open to the public as a historic site. The following year, Carpenters' Hall became the first privately owned building in the country to be opened free as a historic landmark. The c. 1890 photograph below reveals some of the Victorian changes made to the building, including the laying of a Minton tile floor and the installation of gaslight chandeliers.

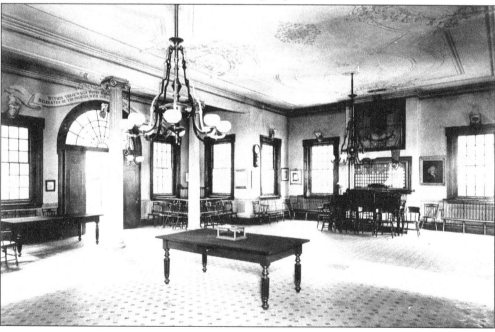

Established in 1834 as the Philadelphia Association and Reading Room, America's oldest social club changed its name to the Philadelphia Club in 1859. The original bylaws limited club membership to 500 men over the age of 21, and its members included individuals from Philadelphia's most prominent families. In 1850, the club moved to its present headquarters, at the northwest corner of Walnut and Thirteenth Streets, a William Strickland-designed building formerly occupied by a young ladies' boarding school.

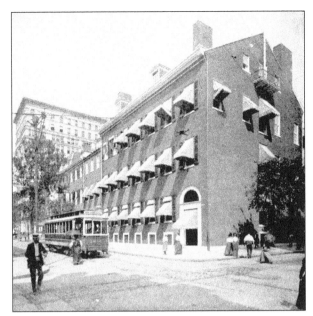

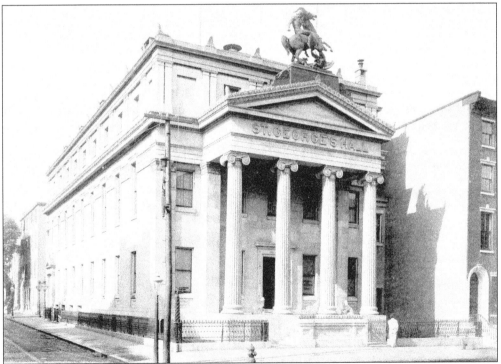

In 1876, the Society of the Sons of St. George moved into the magnificent former residence of Philadelphia railroad magnate Matthew Newkirk, at the southwest corner of Thirteenth and Arch Streets. Founded in 1772, the organization offered aid to needy people of English descent. To accommodate its approximately 700 members, the society altered the Thomas U. Walter–designed building by adding a third story and nearly doubling its length. A statue of St. George slaying the dragon was placed above the front entrance. In 1901, the organization moved west to the 1900 block of Arch Street, and the building, depicted here in the 1890s, was demolished in 1903.

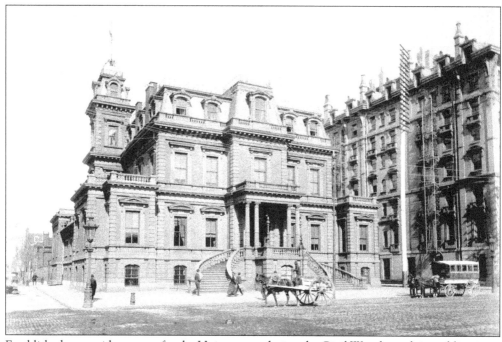

Established to provide support for the Union cause during the Civil War through its publications, fund-raising, and troop recruiting efforts, the Union League erected a clubhouse, designed by Philadelphia architect John Fraser, on the southwest corner of Broad and Sansom Streets between 1864 and 1865. After the war, the Union League remained involved in both local and national politics and counted among its members numerous politicians and prominent businessmen. In the mid-1890s, soon after this photograph was taken, the Union League began expanding its property westward, and by the early 20th century, it occupied the entire block from Broad to Fifteenth Streets.

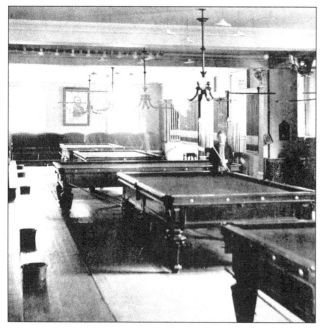

The two main floors of the Union League offered its male members a library, a reading room, parlors, and dining rooms in which to socialize, conduct business, or discuss politics over dinner, drinks, or a good cigar. In the basement, members like this young man, photographed in the late 1860s, could enjoy a game of billiards under the watchful eye of Gen. Ulysses S. Grant's portrait.

In 1855, the Grand Lodge of Free and Accepted Masons of Pennsylvania opened a new hall on the north side of the 700 block of Chestnut Street, the site of an earlier Masonic hall. The Masons occupied the top three floors of the Gothic brownstone building, designed by Philadelphia architect and Mason Samuel Sloan, and rented the first floor out to commercial tenants. Initial enthusiasm for the building faded quickly as problems with water in the basement and poorly ventilated rooms became apparent. By the time of this *c.* 1868 view, a Masonic committee had described the building as "a gross failure both in its plan and its construction."

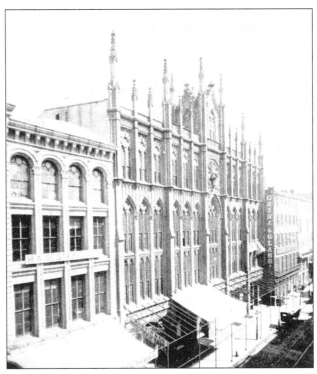

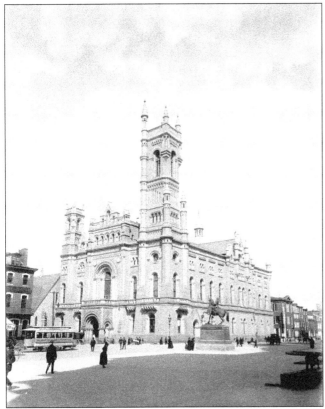

Dissatisfied with their hall on Chestnut Street, the Masons in 1867 purchased four lots at the northeast corner of Broad and Filbert Streets to erect a new building. Construction on the building, designed by Mason James Windrim and modeled after King Solomon's Temple in Jerusalem, was well underway when the building committee received the unwelcome news that Philadelphia's new city hall was to be built across the street at Penn Square. The committee had expected the square to stay undeveloped, allowing passersby an unobstructed view of their majestic building. Now the Masonic temple would have to compete for attention with city hall, the building throwing the shadow in the foreground of this 1890s view.

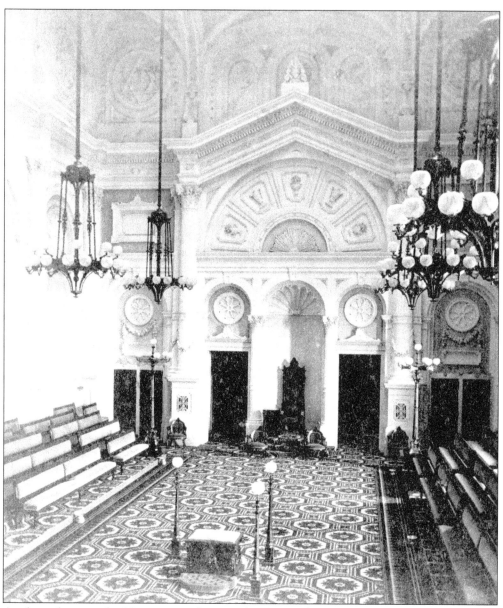

At about the time the Masonic temple opened in September 1873, Philadelphia photographer Frederick Gutekunst documented its impressive interior in which each meeting room represented a different style of architecture ranging from Classical to Egyptian to Norman. This photograph shows the Grand Lodge Room or Corinthian Hall, the temple's largest meeting room, which could hold 800 people. Although basic architectural features were in place in 1873, much of the interior decorating was not completed until early in the 20th century.

Organized in 1827, the Pennsylvania Horticultural Society began with 53 members, who according to their constitution hoped "to inspire a taste for one of the most rational and pleasing amusements of man." In 1829, the Pennsylvania Horticultural Society held its first exhibition, beginning the tradition that continues today as the Philadelphia Flower Show. This c. 1875 view shows an exhibition held in Horticultural Hall, the organization's first permanent home erected in 1867 next to the Academy of Music on the west side of Broad Street below Locust Street.

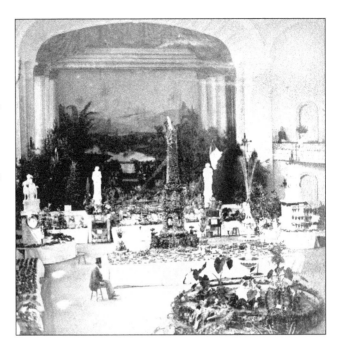

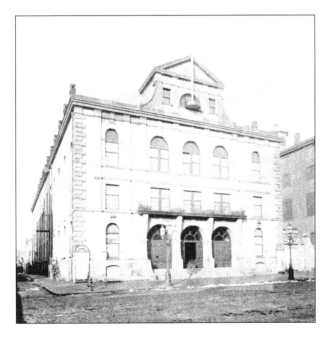

Fire partially destroyed Horticultural Hall in early 1881. The Pennsylvania Horticultural Society rebuilt their headquarters under the direction of Philadelphia architect Addison Hutton at the same South Broad Street location. A year later, the second Horticultural Hall, seen here soon after its completion, opened its doors, but unfortunately in 1893, fire struck again and demolished this building.

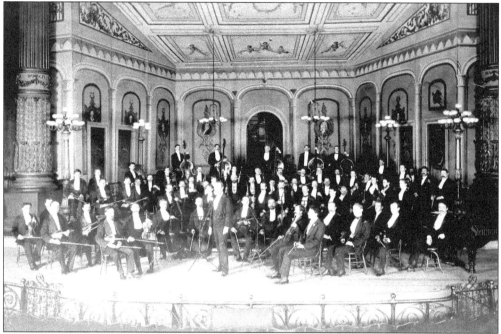

Organist, conductor, and composer William W. Gilchrist founded the Symphony Society of Philadelphia in 1893. This talented group of amateur musicians performed three concerts a year at the Academy of Music. The performance pictured here took place on March 5, 1897. The group disbanded in 1900, selling its music library as well as some instruments and equipment to the newly organized professional Philadelphia Orchestra.

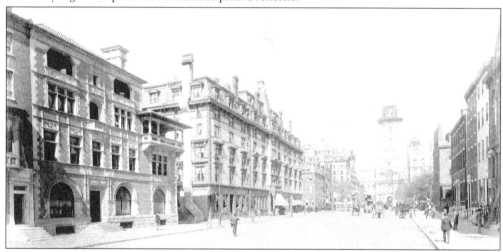

By the late 19th century, South Broad Street was lined with impressive buildings. In the left foreground of this early 1890s photograph stood the headquarters of the Art Club, an organization founded in 1887 to advance the knowledge and appreciation of fine art through exhibitions, lectures, and a library. Here male members could stay overnight, eat, play cards, shoot billiards, and mingle. Except on special days, the club's rules restricted women to one parlor and a ladies' restaurant. This Frank Miles Day–designed building, just north of Locust Street on the west side of Broad Street, was demolished in 1976. Next to the Art Club in this view stood the Stratford Hotel, and immediately north was the Bellevue Hotel.

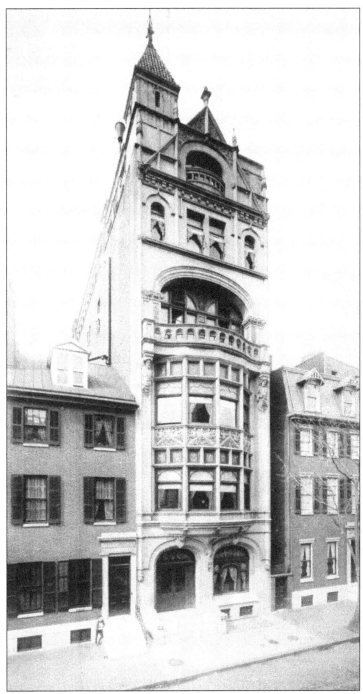

For a $100 entrance fee, businessmen could join Philadelphia's Manufacturers' Club, an organization founded in 1887. Hazlehurst and Huckel, one of the city's prominent architectural firms, designed the clubhouse on the north side of the 1400 block of Walnut Street where the club hosted speakers, held receptions, and provided a convivial social atmosphere for its members. To the right of the clubhouse in this c. 1895 photograph stood the Bellevue Hotel, opened in 1881 in a former private residence.

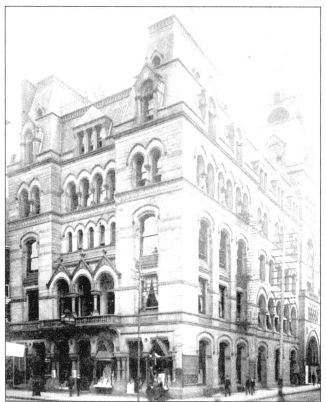

In 1854, the Young Men's Christian Association opened another American branch in Philadelphia with the goal of improving the physical, social, and spiritual well-being of youth living in the city. The group offered religious training, educational lectures, and wholesome recreational activities to its members. Seeking permanent quarters, the YMCA Board purchased a building lot at the corner of Fifteenth and Chestnut Streets in 1872 but struggled to finance construction. The religious revival meetings of Dwight Moody and Ira Sankey held in Philadelphia helped raise the necessary funds, and in 1877, the YMCA moved into the building shown here in the early 1890s.

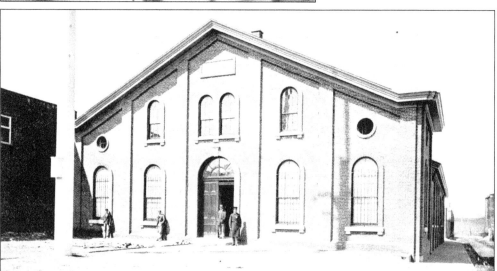

Founded in 1774 to defend the American colonies and still in existence today as the oldest mounted military unit in continuous service in the United States Armed Forces, the First Troop Philadelphia City Cavalry has participated both in combat and at ceremonial occasions. In 1863, the First City Troop erected its first permanent armory, shown here on Twenty-first and Ludlow Streets, for $19,000. The First Troop quickly outgrew this modest two-story brick structure with its riding hall in the rear, and enlarged and altered the building as part of its centennial celebration in 1874. In 1901, the troop moved to its present armory on South Twenty-third Street.

# *Eight*

# MONEY AND TRADE

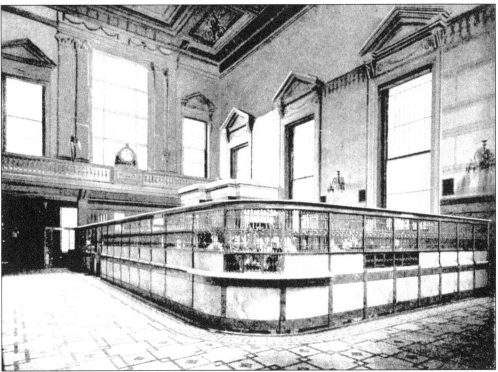

The Bank of North America, the first commercial bank authorized by the federal government, opened its doors in 1782. For almost 150 years, the bank was located on the same lot on the 300 block of Chestnut Street, occupying three successive buildings. Like many early American banks, the bank was initially housed in an ordinary brick storefront owned by the bank's cashier. It was not until 1848 that the company commissioned a structure specifically designed as a bank, and the original building was razed. This 1898 photograph shows the two-story banking room of the third and last building occupied by the bank at this address a few years after the structure, designed by James Windrim, was completed.

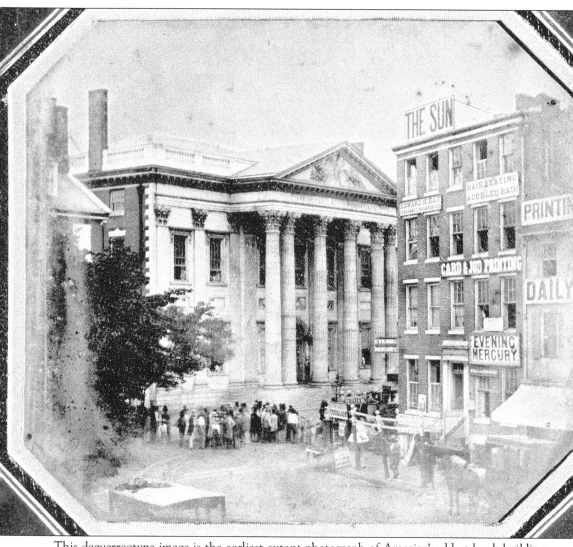

This daguerreotype image is the earliest extant photograph of America's oldest bank building. Constructed between 1795 and 1797 as the First Bank of the United States after designs by Samuel Blodget Jr., the building still stands at 120 South Third Street. Photographers William and Frederick Langenheim captured this view of a crowd gathered in front of the bank, the temporary headquarters of the militia in the aftermath of anti-Catholic riots, on May 9, 1844, creating the earliest known Philadelphia "news" photograph.

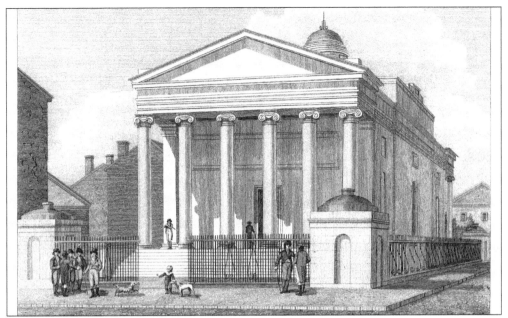

The first of several major public edifices built in the Greek Revival style in the early 19th century, the Bank of Pennsylvania greatly influenced bank design in Philadelphia and other American cities and contributed to Philadelphia's designation as the "Athens of America." Designed by Benjamin Henry Latrobe, the bank, located on the 100 block of South Second Street, contained the first domed banking room in America. The dome motif was echoed in the small pavilions located at each of the four corners of the lot, three of which housed the bank's guards while the fourth served as an outhouse.

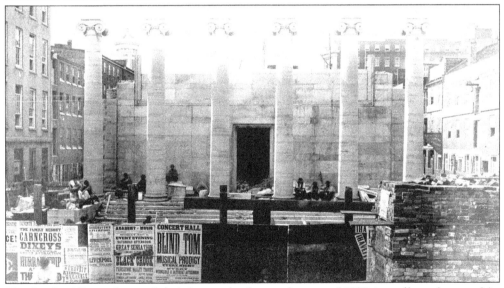

The Bank of Pennsylvania failed during the financial panic of 1857, its collapse hastened by the embezzlement of funds by the bank president Thomas Allibone. During the Civil War, the building was used as a federal prison. Although it was razed for the erection of the U.S. Customs Appraiser's Warehouse in 1867, one of the marble columns from the bank survives as the base of the Sailors and Soldiers Monument in Wilmington, Delaware.

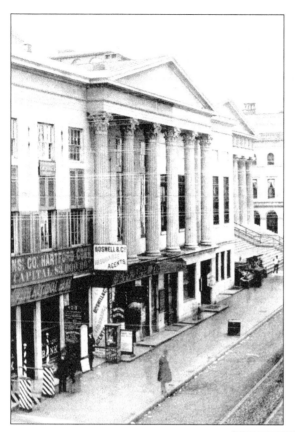

Designed by William Strickland, the Philadelphia Bank building accommodated commercial tenants at street level while the bank occupied the upper floors. Businesses sharing bank premises were chosen with care. Although bank robberies were extremely rare in the 19th century, burglars tunneling into banks through the ground or breaking through the adjoining walls of neighboring structures posed a very real threat to bank security.

The Greek Revival style popular for bank construction in the earlier part of the century gave way to a preference for Italianate designs by mid-century. Known as Bank Row, this impressive group of five banks on the north side of the 400 block of Chestnut Street constructed between 1854 and 1875 features examples of the Italianate style by three of Philadelphia's leading architects—John Gries, James Windrim, and Addison Hutton. Three of the five banks remain and have been adapted for reuse by the American Philosophical Society and DPK&A Architects.

This photograph focuses on two of the extant banks located on Bank Row shown here. When John Gries' design for the building was completed in 1855, the Farmers' and Mechanics' Bank, on the right, was the largest bank in the city. Its smaller neighbor to the left, the Pennsylvania Company for Insurances on Lives and Granting Annuities, was completed in 1873 after designs by Addison Hutton. The building complemented the architectural style of the Farmers' and Mechanics' Bank while using contrasting gray granite rather than white marble for its facade.

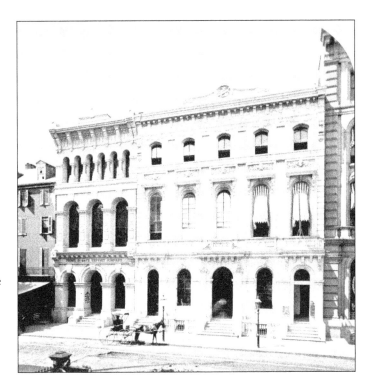

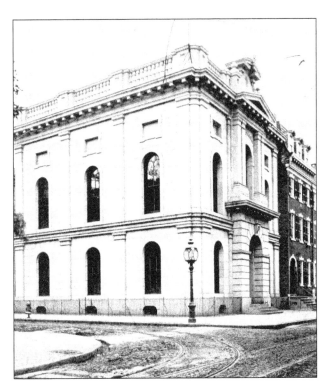

Founded in 1816 as the first savings bank in the United States, the Philadelphia Saving Fund Society (PSFS) commissioned several architecturally significant buildings in the city, the most famous of which is the art deco skyscraper at Twelfth and Market Streets. This photograph shows the granite-faced Italianate structure, designed for the bank by Addison Hutton in 1868, which still graces the northwest corner of Washington Square. Savings banks served the needs of "tradesmen, mechanics, laborers, and domestics" rather than wealthy businessmen and investors. In order to serve a diverse working-class population, PSFS was open for business in the evening and hired multilingual tellers.

93

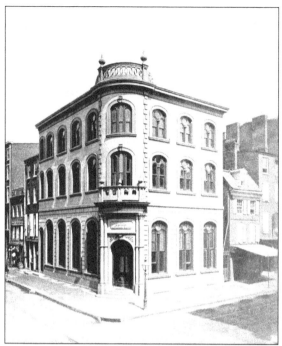

Corner sites enabled banks and other businesses to maintain a presence on two heavily trafficked streets, in this case both Third and Arch Streets, and are still coveted locations. This Italianate structure, designed for the Union National Bank by Richard J. Dobbins in 1868, makes clever use of the site by positioning the entryway at the street corner.

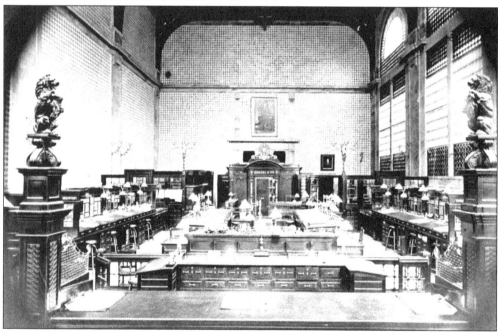

The majesty of the new banking room of Drexel and Company, an influential private bank that primarily served wealthy investors and businesspeople, was designed to inspire confidence in the firm's financial strength. Framed by ornate pillars topped with a matching pair of snarling lions holding the Drexel family's dragon crest, the two-story room also featured a large portrait of founder Francis M. Drexel displayed on the back wall over the vault, and diamond patterned walls. This image dates around the time the building, located at the southeast corner of Fifth and Chestnut Streets, was completed in 1885.

The Guarantee Trust and Safe Deposit Company, established in 1872, provided safe storage for securities, currency, jewelry, silver plate, and other valuables. Safe depositories became more common during the Civil War when the threat to personal possessions in battleground states was very real, and they continued to grow in number and popularity in the years after the war. Frank Furness, the architect of this eclectic brick structure located on the 300 block of Chestnut Street, was commissioned to create plans for almost a dozen financial and trust company buildings in Philadelphia. His idiosyncratic designs provided his clients with visually distinctive structures and also tended to generate a great deal of publicity.

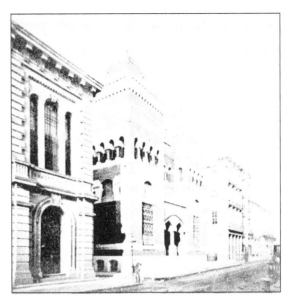

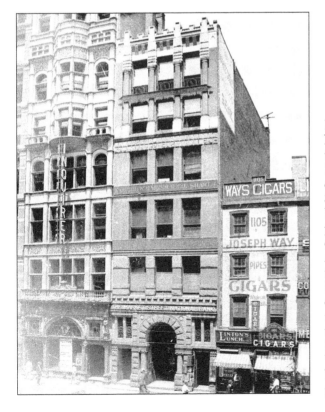

Between the passage of the National Bank Act of 1863 and the 1913 Federal Reserve Act, 7,500 new national banks were established throughout the United States. In most cases, national banks, unlike state banks, were prohibited from owning any real estate except their own buildings. As a result, national banks, like the Market Street National Bank located at 1107 Market Street, commissioned structures that would maximize rental space and income within the bank's own building. Designed by the firm of G. W. and W. D. Hewitt in 1887, Market Street National's building accommodated paying tenants in the upper stories.

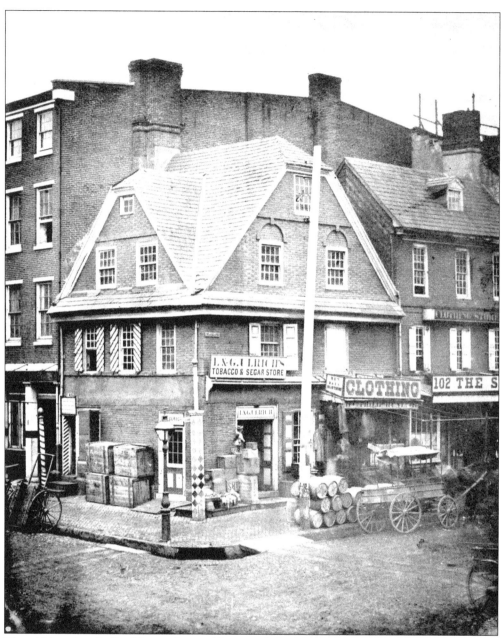

The old London Coffee House, depicted here, and the Merchants' Coffee House (also known as City Tavern) served as informal business exchanges in the 18th and early 19th centuries. Merchants, ship owners, and investors gathered at these establishments to conduct business, advertise their wares, attend auctions, discuss politics and trade, and drink coffee with their associates. This photograph, taken in August 1858, shows the former coffeehouse at the southwest corner of Market and Front Streets occupied by a variety of businesses including a tobacconist, a barber, and a clothing shop.

By the 1830s, the volume and complexity of commercial transactions outgrew the confines of the city's coffeehouses. As a result, Philadelphia's mercantile elite joined together to establish a formal exchange. Designed by architect William Strickland, the Merchants' Exchange building provided space dedicated to the conduct of business and trade. It contained a large exchange floor decorated with mosaic, frescoed walls and ceiling, and a variety of small offices that housed stock brokers, bookkeepers, railway officers, insurance salesmen, and bankers, in addition to a telegraph and post office. The exchange also served as an omnibus depot, and the photograph to the right, taken in June 1859, shows the horse-drawn vehicles parked in front of the striking semicircular portico on the east side of the building. The image below, looking north along Third Street from Walnut Street, shows the plainer western facade of the exchange.

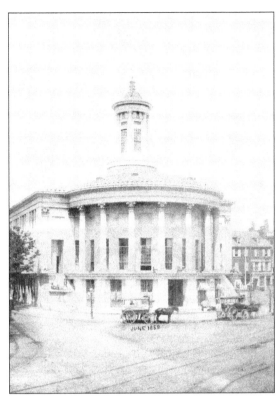

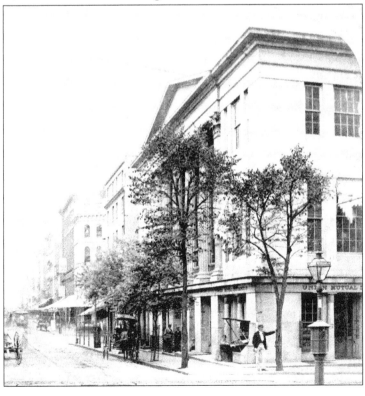

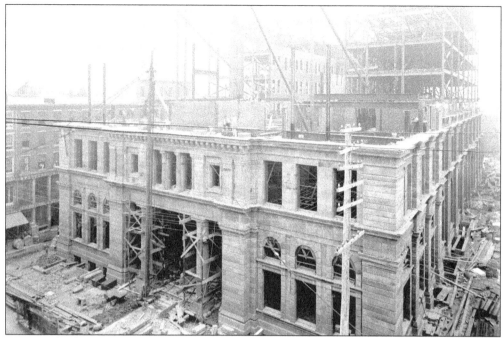

Forming the first American commodities exchange, the massive eight-story, steel-framed Bourse building, constructed between 1893 and 1895, brought together more than a dozen of the city's organized exchanges and trade associations in one building. Brokers, traders, and investors used the Bourse as a source for the latest market news and information. Large quotation boards tracked the prices of stocks as well as major commodities such as grain, coffee, and cotton. Designed by the architectural firm of G. W. and W. D. Hewitt, the facade of Carlisle redstone, brick, and terra-cotta remains a striking feature on Independence Mall.

Like the earlier Merchants' Exchange, the Bourse included a large general exchange floor as well as office space, which was rented out to subsidize the cost of operating the building. In addition, the entire seventh floor and a large portion of the basement were set aside as exhibition halls where local manufacturers could display samples of their wares, including manufactured goods, produce, processed food, raw materials, and machinery, to potential buyers. One of hundreds of display cases on view in the exhibition hall, the case depicted on the left features an artistic arrangement of saws manufactured by Henry Disston and Sons.

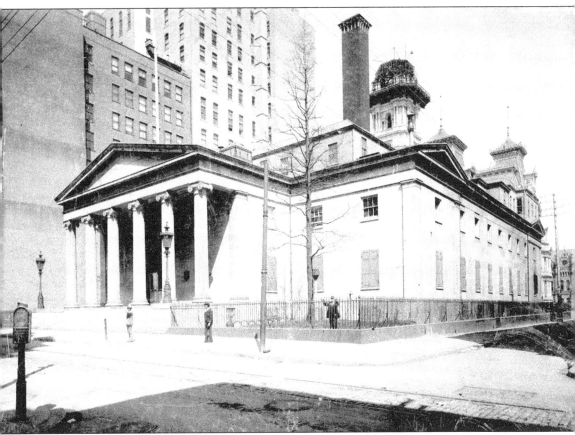

The first United States Mint was established in Philadelphia in 1792. This building, constructed from 1829 to 1833 at the corner of Chestnut and Juniper Streets, served as the second home for the mint and housed its operations until 1901. William Strickland designed the building as a quadrangle with an open central courtyard, which provided natural light throughout the building. By the time this photograph was taken in 1892, the courtyard had been filled in to create additional space for the mint's expansion. The city hall tower, visible behind the tall smokestack, was also nearing completion.

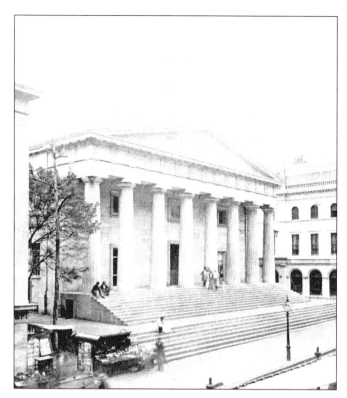

This impressive marble-faced building, constructed between 1821 and 1824 as the Second Bank of the United States after designs by William Strickland, served as the United States Custom House from 1845 to 1935. The entire building from the space under the exterior stairs to the ceiling was constructed with arches "in a bomb-proof manner" intended to discourage attacks on the building by "incendiaries." This 1867 view of the structure showing the Chestnut Street facade includes two street vendors selling produce.

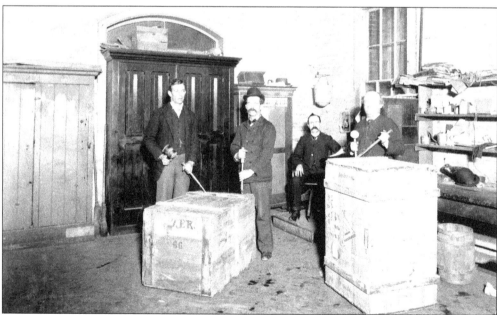

This photograph from the early 1890s shows workers in the U.S. Customs Appraiser's Warehouse on South Second Street preparing to inspect the contents of crates being shipped through the port of Philadelphia. Duties collected on imported goods by the U.S. Customs Service, rather than taxes, provided the primary source of revenue for the federal government throughout the 19th century.

# *Nine*

# EDUCATIONAL
# INSTITUTIONS

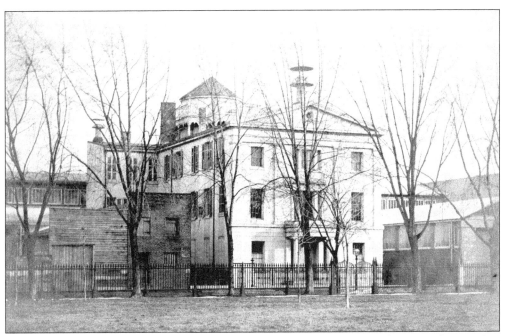

On October 21, 1838, Philadelphia's first four-year public school opened with an enrollment of 89 boys. Central High School, located on Juniper Street between Market and Chestnut Streets, offered superior courses taught by respected faculty. This photograph was taken in 1853, the year the school sold the site to the Pennsylvania Railroad and began construction of a larger school. The observatory tower visible in the background reportedly had better telescopes than Harvard University.

Established by the Society for the Free Instruction of Female Children, the Aimwell School grew out of Quaker Anne Parrish's efforts in 1796 to provide tuition-free education to poor girls. The school enrolled up to 80 pupils for instruction in spelling, reading, writing, arithmetic, sewing, and civic and religious values. In 1825, the school, which accepted students of all faiths, moved into this simple building at 931 Cherry Street, shown here around 1870.

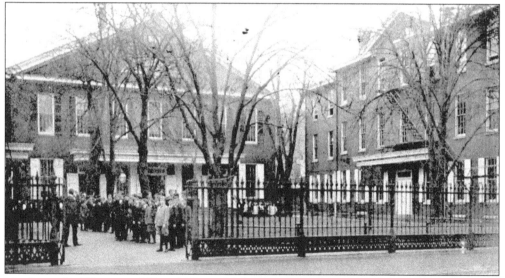

Now located in Wynnewood, Friends' Central School was located at the southwest corner of Fifteenth and Race Streets from 1857 to 1925. After completing the sixth grade, students from various affiliated elementary schools all went to this secondary school, which was established in 1845. Every Fourth Day (Wednesday) morning, students (many of whom were not Friends) were required to attend meeting for worship in the adjacent Race Street Meeting House. A group of young students poses in front of the buildings (school on the right) in this image from the late 1890s.

The congregation of St. Michael's Lutheran Church commissioned prominent Philadelphia architect and builder Robert Smith to construct this schoolhouse at 325 Cherry Street. Completed in 1761, the building faced some disapproval from the reverend because of its cost. Nonetheless, the Zion Lutheran School, as it became known, provided a meeting space for the German Society of Pennsylvania, a parish hall for the Zion Lutheran Church across the street, and room for classes. Antiquarian Charles Poulson's note on this 1859 photograph mentions that the center window on the first floor was originally a front door.

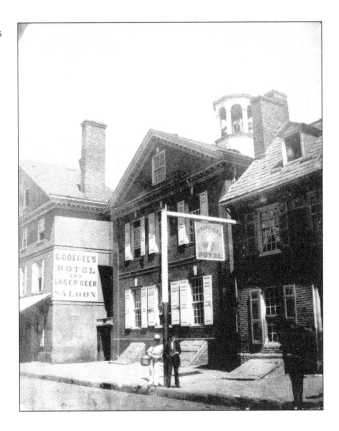

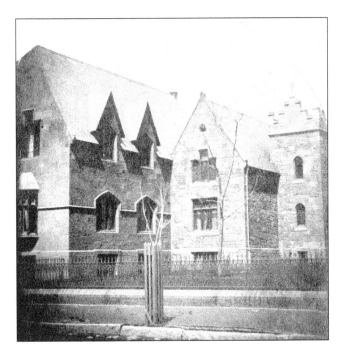

The parish school of Saint Mark's Episcopal Church opened in January 1850, only three months after the church held its first service. Built on the western end of the church lot in the Tudor Gothic tradition after the designs of John Notman, the parochial school served the underprivileged members of the community around 1625 Locust Street until the eve of World War I. This view dated around 1859 shows the L-shaped schoolhouse's steep roofs and tower with battlements and cross.

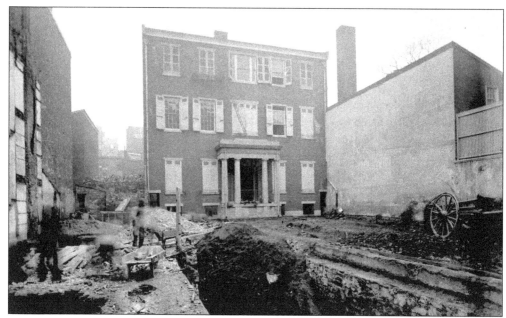

Orthodox Quakers who wished to provide a liberal arts education based on strict, hierarchical religious instruction free from secular influences opened Select School for Boys in 1833. Located in the three-story building shown above at 820 Cherry Street from 1841 until 1886, the school in the mid-19th century suffered from low enrollment (non-Quaker students were not admitted until 1877), financial problems, and a noisy, blighted industrial location. Thus, in 1886, the year of the above photograph, the Select School for Boys and the affiliated Select School for Girls moved into a joint building with separate entrances for boys and girls, on a lot between Sixteenth and Seventeenth Streets above Cherry Street. The schools were later combined as Friends Select School, which still operates at this location. Shown below in 1891, the main building expanded to include a large, well-equipped gymnasium and science laboratories, but was demolished in 1967.

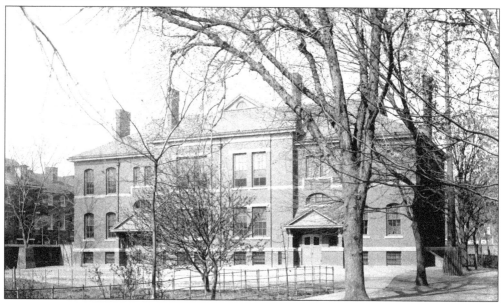

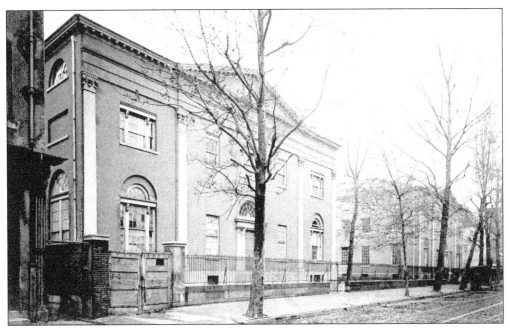

In 1829, the University of Pennsylvania rebuilt its campus on the site where it had been operating since 1802, the west side of Ninth Street between Market and Chestnut Streets. William Strickland designed two Georgian-style buildings with identical marble trimmed facades but with interiors suited to specific uses. Medical Hall, shown in the foreground of this *c.* 1870 view, housed the school of medicine, the first medical faculty formed in the colonies in 1765. College Hall is visible in the background.

Incorporated in 1826, against the wishes of many in the medical community who feared it would create harmful competition with the University of Pennsylvania's medical school, Jefferson Medical College contributed to Philadelphia's importance as the nation's leading medical center during the mid-19th century. At its building on Tenth Street near Sansom Street, shown here around 1855, faculty including Samuel D. Gross and Thomas D. Mütter gave instruction in topics such as surgery, materia medica, and obstetrics and diseases of women and children. The college, known today as Thomas Jefferson University, was the second in the country to open its own teaching hospital to foster student interaction with patients.

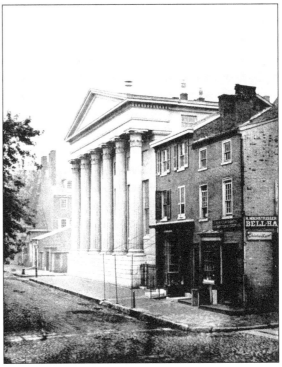

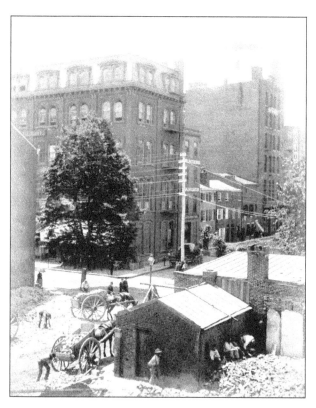

The Pennsylvania College of Dental Surgery was formed in 1856 by faculty of the defunct Philadelphia College of Dental Surgery. The college's five-story building is visible in the background (center left) of this *c.* 1890 photograph documenting the construction of the Reading Terminal at the intersection of Twelfth and Cuthbert Streets. In 1874, Fanny A. Rambarger became its first female graduate and the third female dental college graduate in the country. In 1872, the college graduated John Henry Holliday, later known as the notorious gun-toting gambler "Doc" Holliday. The college merged with the University of Pennsylvania in 1909.

Towering above the surrounding row homes, this building at 252–254 South Ninth Street was constructed in 1849 after the designs of Thomas Ustick Walter. Four different medical institutions occupied the collegiate Gothic–style building in its first three decades, beginning with the Medical Department of Pennsylvania College (of Gettysburg), which merged with the Philadelphia College of Medicine in 1859. This school closed in 1861, and the Eclectic Medical College of Philadelphia moved in. This institution became the Philadelphia University of Medicine and Surgery in 1865. Shown here around 1868, the fraudulent university granted bogus degrees until 1880.

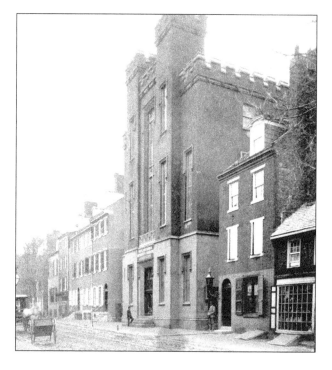

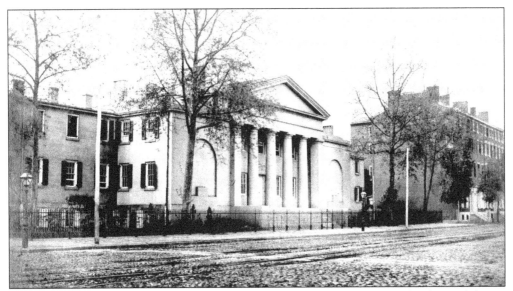

This 1858 view of Broad Street looking northwest from Pine Street depicts the thoroughfare as more structures were springing up near the once rural area. The massive Greek Revival–building, familiar today as the University of the Arts's Dorrance Hamilton Hall, was erected from 1824 to 1826 for the Pennsylvania Institution for the Deaf and Dumb after the designs of John Haviland. This school, chartered in 1821, taught deaf and mute students industrial and trade skills, such as tailoring and lithography. The school left the building in 1893, at which time the Pennsylvania Museum and School of Industrial Art (now University of the Arts) purchased it.

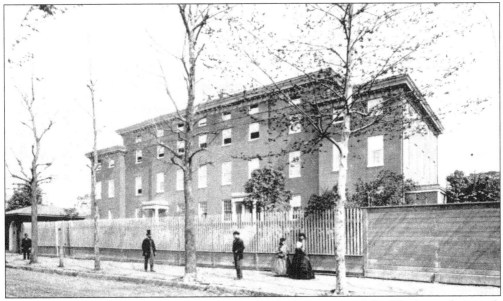

Founded in 1833, the Pennsylvania Institution for the Instruction of the Blind aimed to teach its pupils self-sufficiency through learning skilled trades. The school's buildings at the northwest corner of Twentieth and Race Streets provided classrooms, workshops, and living space for its blind and visually impaired students. The curriculum included elementary through high school courses of study, practical handiwork, and music. In 1869, about the time of this photograph, the school erected a store to sell the students' wares, such as brushes, brooms, chairs, and needlework.

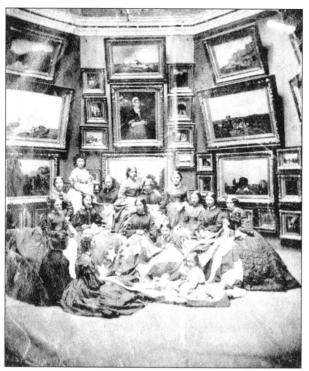

Women were allowed to visit the exhibitions of the Pennsylvania Academy of the Fine Arts starting in 1807 and were first accepted to the prestigious art school in 1848. In the photograph to the left, taken in 1862, a group of patriotic female students poses in the museum's Northwest Gallery with the large Union flag they made. Until 1870, the institution was located at 1025 Chestnut Street, as seen below in that year. The main building, a Grecian style hall originally designed by John Dorsey at the time of the academy's founding (1805) and rebuilt by architect Richard A. Gilpin between 1846 and 1847 after a destructive fire, is visible just through the passageway formed by two retail stores.

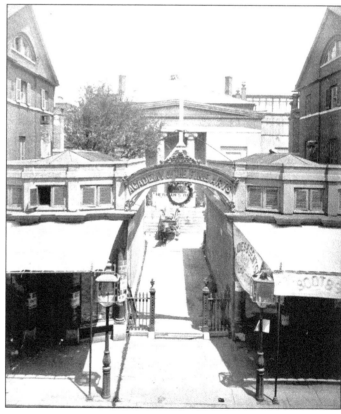

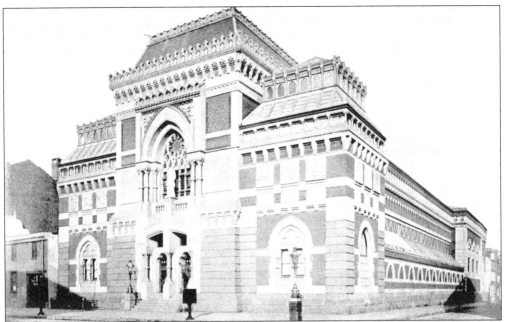

In 1871, a year after selling their Chestnut Street building, the Pennsylvania Academy of the Fine Arts accepted the designs of Frank Furness and George W. Hewitt for a new building, located at the southwest corner of Broad and Cherry Streets. This building was the firm's first major commission and was completed in 1876 just before the opening of the Centennial Exhibition, about the time this photograph was taken. The eclectic design at first drew criticism from cynics who thought it too closely resembled a train station and combined architectural elements in an absurd fashion.

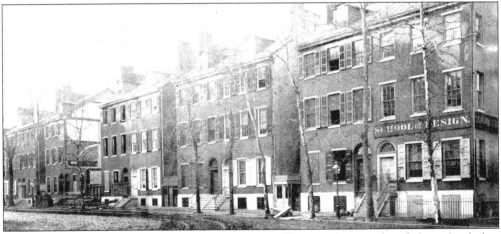

In 1848, as industrialization took hold in Philadelphia, Sarah Peter founded a school that would provide women with the professional skills and knowledge needed to earn a living in the arts. Initially the Philadelphia School of Design for Women prepared students for commercial success in the textile, carpet, paper hanging, and engraving industries. After the Civil War, with prominent Philadelphia engraver John Sartain serving on the board, the curriculum expanded to include the fine arts. Later his daughter Emily became principal. The school is shown here around 1879, when it was located near the northwest corner of Penn Square. Today the school, located on the Benjamin Franklin Parkway, thrives as Moore College of Art and Design.

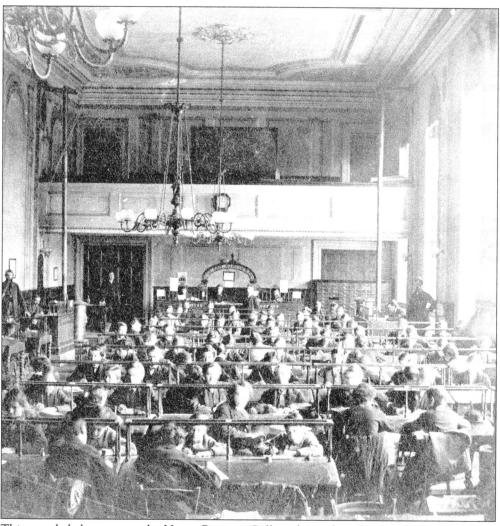

This crowded classroom at the Union Business College, located on the 900 block of Chestnut Street, shows young men and boys studying while instructors look on. Thomas May Peirce founded this practical business school months after the Civil War ended to prepare former soldiers for employment. While this c. 1873 scene shows only male students, the college also opened a ladies department for women seeking work in the business world. Renamed Peirce College, the school still operates today.

# *Ten*

# PUBLIC MARKETS AND SQUARES

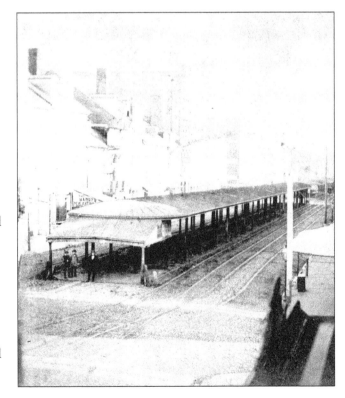

The ramshackle condition of the market sheds for which they were much criticized can be seen in this view taken around 1859 on the 700 block of Market Street. Extended to Eighth Street in 1816, the Market Street sheds were condemned as an impediment to trade and travel and were razed soon after this photograph was taken. Neighboring businesses, such as prominent Philadelphia drug manufacturer J. M. Maris and Company, visible in this view, previously promoted the sheds because the adjacent storefronts reaped the financial benefits of customers attracted by the market.

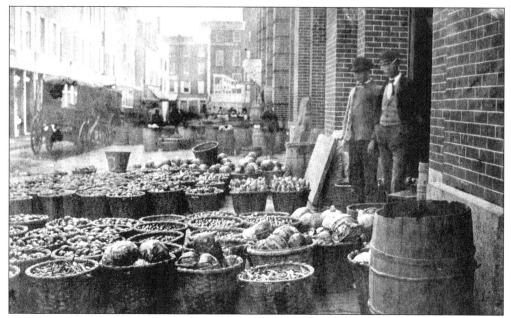

This 1859 view shows baskets of produce waiting to be sold on the opening day of Eastern Market, one of the first market buildings built to replace the Market Street sheds. Erected in November 1859 at Fifth and Merchant Streets by the Eastern Market Company, the company included such prominent shareholders as future mayor Morton McMichael, former mayor Richard Vaux, and architect Thomas U. Walter. The market regulations required that half the stalls be reserved for Pennsylvania farmers.

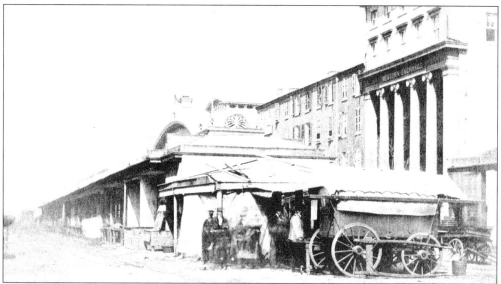

In 1830, a western branch of sheds on Market Street was built between Fifteenth and Seventeenth Streets. Known as the Western Market, the stalls stood near the Western Hotel, a resting spot for many of the farmers who rented at the market. The hotel also served as a western terminus for several omnibus lines. The market sheds were removed soon after this 1859 photograph was taken and replaced by the Western Market House at Sixteenth and Market Streets. A year later, the hotel met the same fate as the sheds.

This 1859 construction view shows the Franklin Market, designed by Philadelphia architect John McArthur Jr., on the 100 block of Market Street. Built by the Centre Market Company to house several of the displaced farmers and butchers, who previously occupied sheds on Market Street, the market house, named in honor of Benjamin Franklin, accommodated nearly 300 stalls under its fireproof roof. Around 1864, as a result of poor business, the market relocated to a different facility at Twelfth and Market Streets adjacent to the successful Butchers' and Farmers' Market.

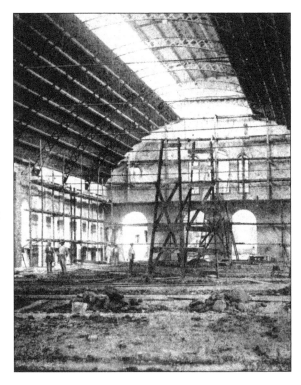

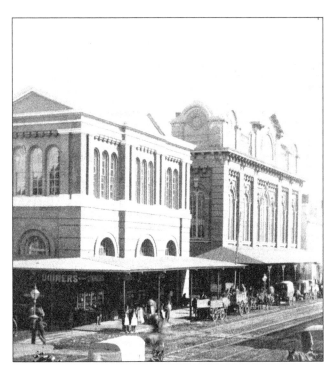

The Franklin Market (left), more commonly known as the Twelfth Street Market, and the Butchers' and Farmers' Market (right) were two of the four market houses built between 1859 and 1875 on Market Street after the removal of the sheds. The Butchers' and Farmers' Market, completed in 1859, was the largest of the new market houses and was constructed using scraps from the razed market sheds. The two markets contained nine block-long aisles lined by stalls that rented for prices ranging from around $14 to $125 a month. As visible in this c. 1869 view, wagons lined the 1100 block of Market Street to make and receive deliveries throughout the day.

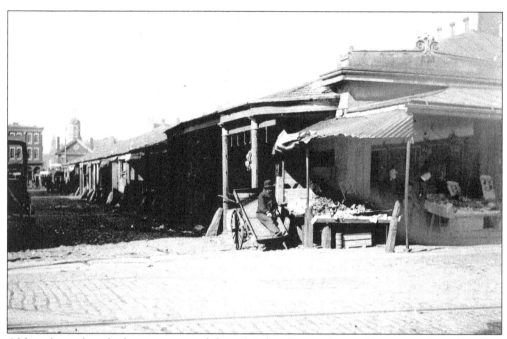

Although market sheds were removed from Market Street almost 40 years earlier, this 1898 photograph shows public markets governed by the city still remained on adjacent streets. The Headhouse Market, originally known as the New Market, was erected in 1745 on the 400 block of South Second Street. Built to accommodate the growing number of South Philadelphia residents who did not wish to travel to the Market Street market stalls, the market was not razed until 1956. The fire engine house, known as a headhouse, built in 1804 and for which the market was renamed, is visible in the distance on Pine Street.

Not many interior photographic views of markets exist because the congestion and hectic environment of these public venues made taking photographs impractical for 19th-century photographers. This rare c. 1885 view shows George Stockburger's butcher stall at the Headhouse Market at Second and Pine Streets. The meat hanging from hooks on the side of the stall and displayed on uncovered counters and a table reflect the sanitary standards of the 19th century.

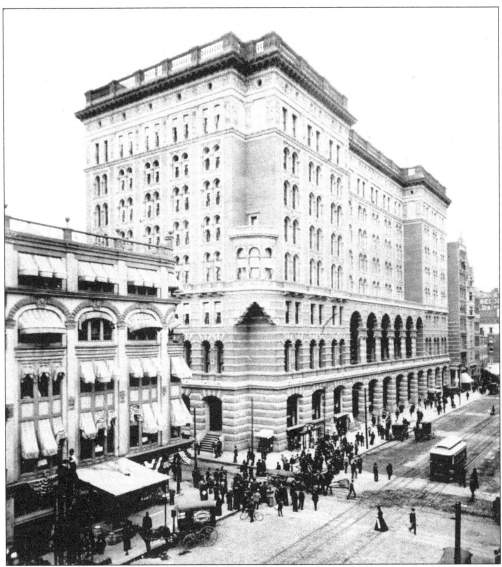

The Reading Terminal Market, the largest market in the world at the time of this c. 1895 view, was built between 1891 and 1893 in the Philadelphia and Reading Railroad terminal after the designs of Wilson Brothers and Company. Under the supervision of market superintendent George McKay, the modern facility at 1115–1141 Market Street opened on February 22, 1892, tenanted by the transplanted vendors of the Farmers' and Twelfth Street Markets. Built with a cold storage basement and stalls of oak and marble, the market of 800 vendors quickly became known for its quality goods. The Hotel Vendig, built in 1891, is also visible at the left.

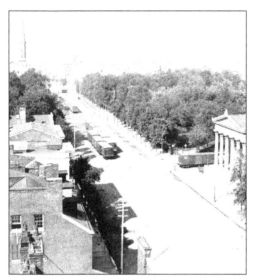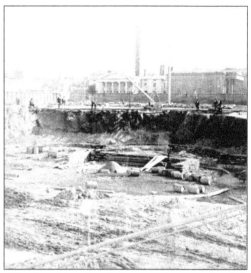

Taken from the rooftop of the La Pierre House Hotel at Broad and Sansom Streets, the left view shows Penn Square shortly before it was removed in 1871 for the construction of the new city hall designed by Philadelphia architect John McArthur Jr. Over the next 30 years, the tree-covered plazas and this section of Broad Street, utilized by the freight cars visible en route to the distant depot of the Reading Railroad at Cherry Street, would disappear underneath the imposing edifice. The right view, taken as part of a series of progress photographs by James Cremer, shows the pitted square stocked with construction supplies in December 1873. The lower view, taken around 1896, shows the north side of city hall with the tower, begun in 1884, in the final stages of construction.

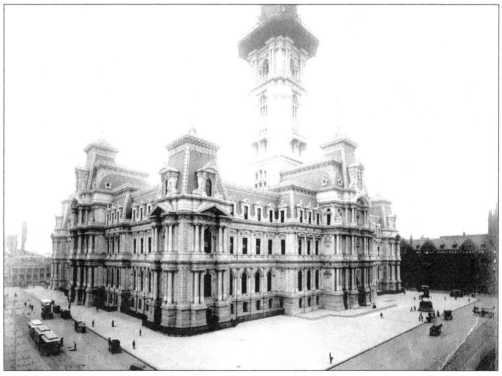

This view shows the snow-covered plaza between Race, Vine, Sixth, and Franklin Streets, originally known as the Northeast Square and renamed Franklin Square in honor of Benjamin Franklin. The square, described by visitors in the 1850s as a bucolic haven within the city, was previously used as a pasture, a burial ground for the neighboring German Reformed Church, and a drilling ground for troops. This 1860 winter view shows the many trees of the square lining paths that had been fitted with rows of small stools to discourage loitering. The square also contained a noted central marble fountain built in 1837 that can be seen in the c. 1870 photograph below. The fountain was one of several improvements to the square following the relinquishment of the grounds by the German Reformed Church around 1836.

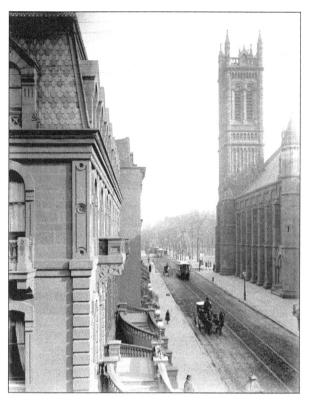

By the mid-19th century, the area surrounding Rittenhouse Square, originally called the Southwest Square, had been redeveloped from brickyards into elegant residences for the upper middle class. A glimpse of the brownstones typical to the neighborhood is visible opposite Holy Trinity Church in this 1888 view of the square taken by amateur photographer J. Howard Gibson from the second floor window of his home on the 2000 block of Walnut Street. Renamed for the prominent astronomer David Rittenhouse, the square between Eighteenth, Nineteenth, Walnut, and Locust Streets nearly became the site of an astronomical observatory, instead of home to fountains that eventually adorned three of its entrances.

Donated in 1872 to the Philadelphia Fountain Society by prominent Philadelphia civil engineer and art collector J. Gillingham Fell, the ornate fountain at the northwest corner of Rittenhouse Square (at Walnut and Rittenhouse Streets) mirrored the wealth of nearby residents. Although beautiful, the fountains contained faulty plumbing, which caused muddy conditions intolerable to visitors, and the structures were removed by the early 1880s.

This c. 1870 view subtly captures a defining element of Washington Square. The square, bounded by Sixth, Eighth, Walnut, and Spruce Streets, was known for its superior variety of trees. The grounds, once a potter's field, had been transformed by the mid-19th century into a city arboretum of over 60 species. The square also held the distinction of being the site of the first public drinking fountain. Erected by the Philadelphia Fountain Society in the spring of 1869 at Seventh and Walnut Streets, the fountain included an eagle by the prominent Philadelphia ironwork firm Robert Wood and Company, as well as provided water troughs for horses and dogs.

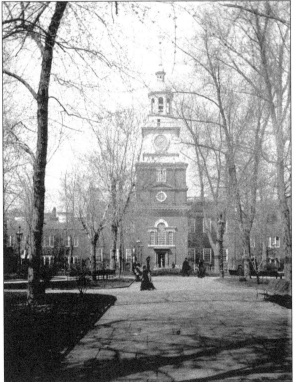

Originally known as the State House Yard, Independence Square, on the 500 block of Walnut Street, was purchased in 1729 by the Pennsylvania Assembly for the erection of the State House. When the city bought the square in 1816, the undeveloped portion north of Walnut Street had been enclosed by fencing and was used as a public green for community meetings and demonstrations. The above view, taken in 1887, shows the square after its major redesign into geometric form and includes the new flagstone walks, from the plans of William Dixey, city commissioner of property.

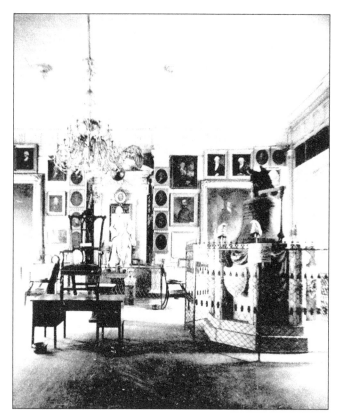

The architectural symbol of the birth of the nation, Independence Hall (also called the State House) was built 1732–1748 after the designs of architects Andrew Hamilton and Edmund Woolley. Although used as a municipal building, by the time of this 1865 view, the hall had also become a national shrine for the display of artifacts associated with the founding of the nation. Within the assembly room, a visitor viewed Philadelphia sculptor William Rush's 1815 wood statue of George Washington; the Liberty Bell; Philadelphia artist Charles Willson Peale's portrait collection of Revolutionary War heroes; and the "Rising Sun" chair, used by George Washington as he presided over the Constitutional Convention.

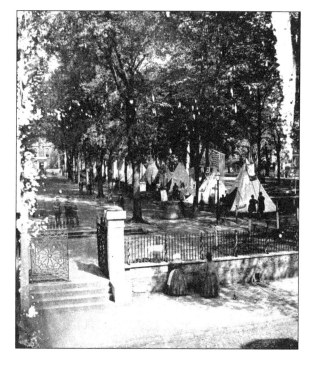

From September to October 1862, Independence Square was transformed into the Civil War recruiting camp, Camp Independence. In an effort to avoid a statewide draft, recruiters manned 25 tents along the main thoroughfare amid a band playing patriotic music and under the gaze of dutiful spectators. A few thousand of the over 80,000 Philadelphians who served in the military during the Civil War enlisted at this site, one of the most successful in the city.

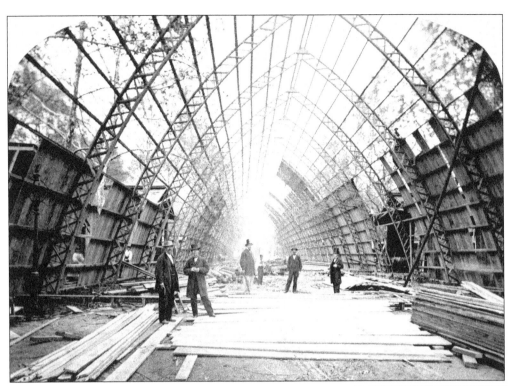

During the Civil War, many benevolent and relief organizations were formed to aid soldiers and their families. One of the largest was the U.S. Sanitary Commission, which held fund-raising fairs in a number of major cities in the North, including Philadelphia at Logan Square, June 7–28, 1864. Often temporary buildings, such as this one, built for the main thoroughfare after designs by Strickland Kneass, were constructed to house the art, craft, industrial, and historical exhibits. Fair offerings included product displays; a re-creation of an 18th-century German-American kitchen; a horticultural exhibit containing a fishpond; and a miniature model house showcasing the most desirable construction methods of that time. Shown to the right is one of the product display booths on the fair's main thoroughfare, Union Avenue.

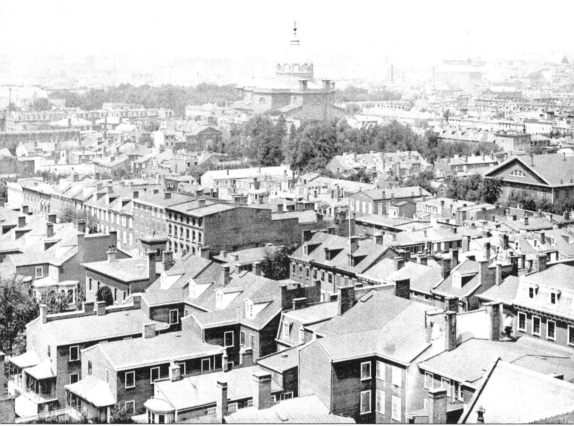

This c. 1867 birds-eye view looking northwest from Seventh and Chestnut Streets shows Logan Square, west of Penn Square at the Cathedral Basilica of SS. Peter and Paul, between Eighteenth, Nineteenth, Vine, and Race Streets. Originally known as the Northwest Square, the plaza was renamed in honor of James Logan, secretary to William Penn. During the 18th and 19th centuries, the site served as a burial ground, pasture, and an arena for public executions. By 1864, when the square was used as the venue of the Sanitary Fair, the area served solely as a promenade. In the 1920s, the square was altered to a traffic circle as part of the construction of the Benjamin Franklin Parkway.

# SELECTED BIBLIOGRAPHY

Athenaeum of Philadelphia. "The Philadelphia and Architects Building Project." http://www.philadelphiabuildings.org

Belfoure, Charles. *Monuments to Money: The Architecture of American Banks*. Jefferson, NC: McFarland and Company, Inc., Publishers, 2005.

Blodgett, Lorin and Edwin T. Freedley. *Philadelphia and Its Industries*. Philadelphia, 1885.

Charles A. Poulson Scrapbooks. 11 vols. Library Company of Philadelphia.

Glazer, Irvin R. *Philadelphia Theaters: A Pictorial Architectural History*. New York: The Athenaeum of Philadelphia and Dover Publications, Inc., 1994.

Holt, Glen E. "The Changing Perception of Urban Pathology: An Essay on the Development of Mass Transit in the United States." Chap. 18 in *Cities in American History*. New York: Alfred A. Knopf, Inc., 1972.

Jackson, Joseph. *America's Most Historic Highway: Market Street, Philadelphia*. New edition. Philadelphia: John Wanamaker, 1926.

Jackson, Joseph. *Encyclopedia of Philadelphia*. 3 vols. Harrisburg: The National Historical Association Telegraph Building, 1931.

Jackson, Kenneth T. *Crabgrass Frontier: The Suburbanization of the United States*. New York: Oxford University Press, 1985.

Maynard, W. Barksdale. *Architecture in the United States 1800–1850*. New Haven: Yale University Press, 2002.

O'Gorman, James F., Jeffery A. Cohen, George E. Thomas, G. Holmes Perkins. *Drawing Toward Building: Philadelphia Architectural Graphics 1732–1986*. Philadelphia: University of Pennsylvania Press, 1986.

O'Neil, David K. *Reading Terminal Market: An Illustrated History*. Philadelphia: Camino Books, 2004.

Philadelphia Society for Organizing Charitable Relief and Repressing Mendicancy. *Manual for Visitors among the Poor with a Classified and Descriptive Directory to the Charitable and Beneficent Institutions of Philadelphia*. Philadelphia: Lippincott and Company, 1879.

Rilling, Donna J. *Making Houses. Crafting Capitalism: Builders in Philadelphia 1790–1850*. Philadelphia: University of Pennsylvania Press, 2001.

Roberts, Jeffrey P. "Railroads and the Downtown: Philadelphia, 1830–1900." Chapter 2 in *The Divided Metropolis: Social and Spatial Dimensions of Philadelphia, 1800–1975*. Westport, CT: Greenwood Press, 1980.

Scharf, J. Thomas, and Thompson Westcott. *History of Philadelphia. 1609–1884*. 3 vols. Philadelphia: L.H. Everts and Company , 1884.

Thomas, George E., Jeffrey A. Cohen, Michael J. Lewis. *Frank Furness: The Complete Works*. Revised edition. New York: Princeton Architectural Press, 1996.

Toll, Jean Barth and Mildred S. Gillam, comps. and eds. *Invisible Philadelphia: Community through Voluntary Organizations*. Philadelphia: Atwater Kent Museum, 1995.

Watson, John Fanning. *Annals of Philadelphia, and Pennsylvania, in the Olden Time;....* 3 vols. Enlarged with many revisions and additions, by Willis P. Hazard. Philadelphia: Edwin S. Stuart, 1884.

Weigley, Russell, ed. *Philadelphia: A 300-Year History*. New York: W. W. Norton and Company, 1982.

White, Theo B. *Philadelphia Architecture in the Nineteenth Century*. Philadelphia: University of Pennsylvania Press, 1953.

Wolf, Edwin, 2nd. *Philadelphia: Portrait of an American City*. Philadelphia: Camino Books in cooperation with the Library Company of Philadelphia, 1990.

# SUBJECT INDEX

# STREET INDEX

# INDEX TO IDENTIFIED PHOTOGRAPHERS

The position of the image on the page is indicated after the page number with a "b" for bottom or "t" for top. About one-fourth of the photographs contained in this book are unsigned and the photographers are unknown. Only the identified photographers are included in this index.

# Index to Architects

Printed in the USA
CPSIA information can be obtained
at www.ICGtesting.com
LVHW070757241223
767241LV00009B/902

9 781531 627461